EASY
CREATIVE LETTERING

easy CREATIVE lettering

A STEP-BY-STEP GUIDE TO LETTERING, flourishing & MORE

Missy Briggs

ROCKRIDGE
PRESS

To My Love

For general information on our other products and services or to obtain technical support, please contact our Customer Care Department within the United States at (866) 744-2665, or outside the United States at (510) 253-0500.

Rockridge Press publishes its books in a variety of electronic and print formats. Some content that appears in print may not be available in electronic books, and vice versa.

TRADEMARKS: Rockridge Press and the Rockridge Press logo are trademarks or registered trademarks of Callisto Media Inc. and/or its affiliates, in the United States and other countries, and may not be used without written permission. All other trademarks are the property of their respective owners. Rockridge Press is not associated with any product or vendor mentioned in this book.

Interior and Cover Designer: Jami Spittler
Art Producer: Karen Williams
Editor: Claire Yee
Production Editor: Emily Sheehan

Photography © Jennifer Hale, pp. 106, 108, 110, 112, 114, 116, 118, 120, 122; Author photo courtesy of © Jessica Lopez.

ISBN: Print 978-1-64611-505-1

R0

Contents

Introduction

For as long as I can remember, I've doodled letters. My first job at age 14 was drawing on a menu board in a restaurant. I still have notes from high school with block lettering scrawled across the front with inky dots from a blue Bic pen. After high school, I went to art school and spent a good portion of time in the studio, working and connecting with fellow students. I loved crafting and painting but couldn't see any of that as a marketable skill. I stopped creating and took practical day jobs for the next 10 years. (If I could tell you about my wasted twenties, we would laugh and have a good ugly cry together after you shared your own failed moments; we would run out for boba, become besties, and then you would be ready to read about lettering.)

I wasn't sure exactly when I stopped being an artist, but there I was: in a cubicle farm, looking nothing like the creative I was born to be. I caught the lettering bug in 2015 and started off by sharing some of my work on Instagram. From there, I found a community of creatives that provided the connections I missed from art school. They were hobbyists, side hustlers, and artisans. They didn't need to label their vocations; they just needed an outlet to share their work and ideas.

What started as a way to hone my skills and dip my toe back into my art turned into a full-time job. Today, I use my roundabout journey into art as an example to encourage my own children to always follow their passions. I may have taken a hiatus from my artistic pursuits and a detour in my career, but I am and will always be an artist. *It's never too late to start your creative life!*

If you're using this book to dive back into your own creativity, congratulations! You're learning lettering at a perfect time, because it's everywhere. The next time you visit your favorite store, take notice of hand lettering on calendars, journals, pillows, packages, and signage. Trader Joe's is a Pinterest board of hand-lettered signs and chalkboard art. The good news is that creative lettering is easy to learn! It combines two things you already know how to do: draw the alphabet and doodle.

I believe we all have a deep desire to create. When you think about it, you create and curate constantly. Think about dinner last night. You chose and adapted that recipe. You edited your wardrobe before you shopped for new clothes. You sorted through your makeup to create a fresh on-trend look. You put together a scrapbook for your mom. These small acts of curating and creating a life you love are the acts of an artist! I believe in blurring the lines between creators, artists, and artisans. We are all creators, and I can't wait for you to get started with your next creative obsession: lettering!

This book is organized into three sections. First, we'll go over the basics of creative lettering and trim your art supply shopping list down to a few must-have items. Next, we'll review 10 creative lettering alphabets that use different techniques and styles, with space for you to practice. In the last section, we'll practice combining our basic lettering skills to create compositions with embellishments. In the last chapter, you'll find eight different creative projects that use hand lettering, complete with step-by-step instructions and downloadable templates. I love learning new ways to use my creative lettering skills, and I think you will, too!

An Illustrated Lettering and Typography Glossary

Let's start with a glossary of the lettering terminology I'll use in the book. Lettering artists, calligraphers, and type designers use a lot of unfamiliar terms to describe parts of a letterform and the spaces in between. This list isn't exhaustive, but it's a good introduction.

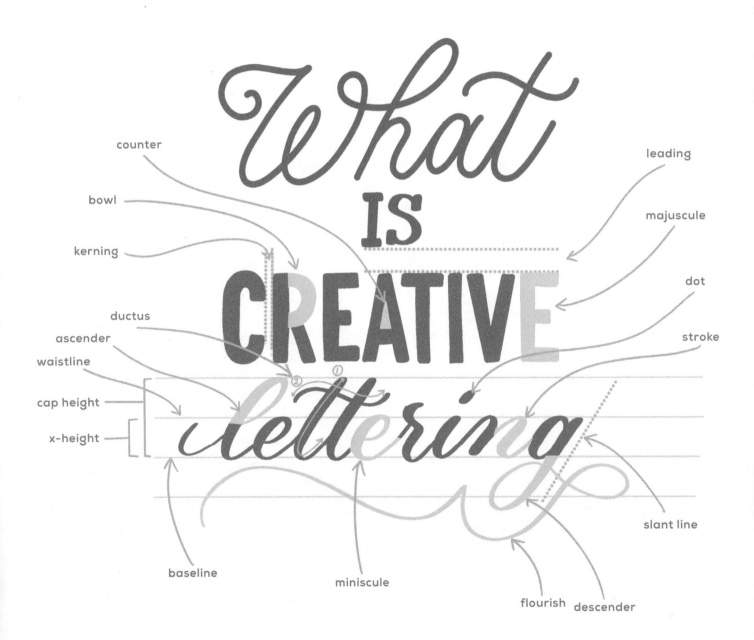

ascender: A portion of a letter that extends above the **waistline**

baseline: The line on which letterforms sit

bowl: The closed, rounded part of the letter, as seen in *b, d, p,* and others

cap height: The height of a capital letter

counter: The enclosed center portion of a letter, as seen in *b, d, o,* and others (The interior of an *e* is called an *eye.*)

descender: The portion of a letter that falls below the **baseline**

dot: A small circle, also called a *tittle,* used atop a lowercase *i* or *j*

ductus: A rule of letter creation that dictates the order in which strokes are made to form letters

flourish: Decorative swirls attached to a letterform, sometimes free-floating as embellishments

kerning: The horizontal space between two letterforms

leading: The vertical space between two lines of text

letterform: A drawn or digitally designed letter of the alphabet

majuscule: An uppercase letter

miniscule: A lowercase letter

monoline: A type of lettering in which all letterforms are drawn using lines of equal weight

negative space: The blank space around and between letterforms or words

sans serif: A letter drawn or a font designed without any added decorative strokes

serif: A letter drawn or a font designed with small decorative strokes at the end

slant line: A slanted guideline used to line up the axis of a letter; in calligraphy, it is usually set between 52 and 55 degrees

stroke: Any mark made to form a letter

waistline: The height of a lowercase *x,* also commonly called the *x-height*

weight: The relative width of a stroke

Part ONE

Creative Lettering 101

DO WHAT YOU *love* AND DO IT *often*

Chapter One

A Quick-Start Guide to Creative Lettering

Let's jump into your creative lettering journey! This chapter will set you up with the basics to get started. You'll find out what creative lettering is (and what it's not). We'll cover a few essential materials to purchase and how to get your bearings in an art supply store. You'll also find game-changing rules that will give you the confidence to go forth and create beautiful letters of your own.

What Is Creative Lettering?

Creative lettering is a decorative art form of hand drawing letters. If you look up the terms *creative lettering*, *calligraphy*, and *fonts*, you'll find that they are often used interchangeably. To differentiate them in the fewest possible words, you could say: *Calligraphy is creative lettering, but creative lettering is not always calligraphy. Fonts are neither calligraphy nor creative lettering.*

Let's take a closer look at the image to the right. The letter on the left (A) belongs to a font. It was designed by someone (not me) and is distributed en masse in print materials. Fonts are digitally designed letterforms. Individual letters and symbols are created once and uploaded together as a set of glyphs. The glyphs vary in size, but otherwise, they do not change. When you type a letter *A* in a particular font, it will always look the same.

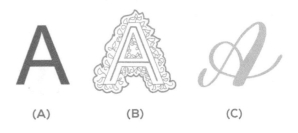

(A) (B) (C)

The letters in the middle (B) and on the right (C) are both examples of creative lettering. The middle letter was drawn by hand and later digitized. The letter on the right is an example of brush calligraphy—it was drawn by hand using multiple pen strokes with varying amounts of pressure to increase or decrease the weight (or width) of each stroke.

Creative lettering is a broad term used to describe letters that are drawn by hand or with digital tools. You can draw letters with a pencil, pen, marker, fountain pen, traditional dip pen with a nib, or a paintbrush—pretty much anything that makes a mark! Calligraphy is a specific type of lettering that involves drawing individual strokes using a pen or a brush to create letters.

You don't need to have pristine or beautiful handwriting to learn creative lettering. This is a common misconception! In fact, when practicing creative lettering, you're not writing at all—you're drawing. Creative lettering involves drawing a series of simple shapes to form letters. Everyone can do this with practice, regardless of their handwriting.

There are 10 unique practice alphabets in this book in three different styles: script, serif, and sans serif. This book includes 5 script alphabets as well as 5 serif and sans serif alphabets. Each alphabet includes a complete sample with stroke-by-stroke instructions for all capital and lowercase letters, followed by practice space.

Script lettering (D) is a way to create letters with connected strokes. Think of cursive handwriting but written stroke by stroke, instead of in one fluid motion.

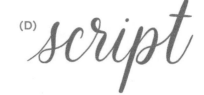

(D)

Serif lettering (E) uses serifs, little lines or shapes at the end of each stroke. Serifs were initially designed for fonts—to help lead the eye horizontally across a page. They serve the same purpose in lettering but can also be exaggerated for effect. Serif letters are not connected to one another.

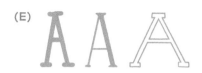

Sans serif lettering (F) is similar to serif lettering in that letters are not connected. The word *sans* means "without"—as such, sans serif letters do not have serifs at the ends of strokes.

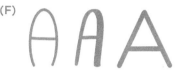

Within each of these three different ways to form letters, you'll also learn three modern styles of creative lettering:

Brush calligraphy and brush sans serif (G) are popular styles of lettering. In the images to the right you'll notice that each letter contains both thin and thick lines. The thickness (or weight) of each stroke is formed by applying different pressures with brush pens or paintbrushes.

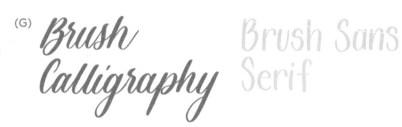

Monoline serif and monoline sans serif (H) are styles of creative lettering in which all letterforms are drawn using lines of equal width (or weight) with a round pen. This involves easy-to-learn techniques and a lot of creative freedom.

Faux calligraphy (I) is a style drawn using a round pen that mimics the thick and thin lines associated with brush lettering. The variations of weight in the letterforms are achieved by drawing them and coloring the shaded areas.

Your Essential Lettering Tool Kit

Now that you know the terms associated with lettering, let's turn to the materials! This section will cover the beginner-friendly pencils, pens, and paper you need for creative lettering.

PENCILS

The best pencil to use is the one you most likely already have—a basic yellow graphite pencil labeled "HB." HB pencils are manufactured to be easily erased without leaving marks or indents on paper. Hard graphite pencils (9H to 2H) will erase but can leave an indentation in the paper, which will be noticeable after you erase a mark. Soft graphite pencils (2B to 9B) leave a darker black mark, which is difficult to erase completely. Soft graphite pencils are ideal for drawing and shading, and hard graphite pencils are used almost exclusively for writing since they don't need to be sharpened as often. Balanced pencils that fall in the middle of the scale—like HB—are perfect for lettering! My preferred pencil is the Blackwing Pearl, which I like for its beauty as well as its balanced graphite. I find it to be smoother than competing pencils.

ERASERS

When choosing an eraser, you're just looking for something that will cleanly remove pencil marks. For beginners, I recommend a white plastic eraser. I once took a drawing class and had to use a jeweler's loupe and a craft knife to remove stray ink from coated presentation boards. You're not getting that technical. If you have an eraser that can cleanly remove pencil marks from the paper, use it! If you need to buy one, I recommend the Pentel Hi-Polymer Eraser.

BRUSH PENS

Brush pens come in a couple of forms: They can be spongy-tipped markers or pens that have bristles like a paintbrush. They have a flexible tip to create thin and thick lines. The practice alphabets in this book are to be drawn with a small brush pen, which is more suitable for beginners. If you don't already have one, go ahead and buy both a small and a large brush pen. The large brush pen can create beautiful letters that are twice as large as those drawn with the small pen. There are a myriad of gorgeous pens to try in an endless rainbow of colors, but I recommend starting with these basics: for the small brush pen, the Pentel Arts Sign Pen, Brush Tip or Tombow Fudenosuke Soft Tip; for the large brush pen, the Tombow USA Dual Brush Pen.

PRO TIP

You don't have to throw away old pens. I have a few large water-based brush pens that have frayed and are no longer functional for intricate brush lettering. These pens are still chock-full of ink, so I use them to color in my journal instead.

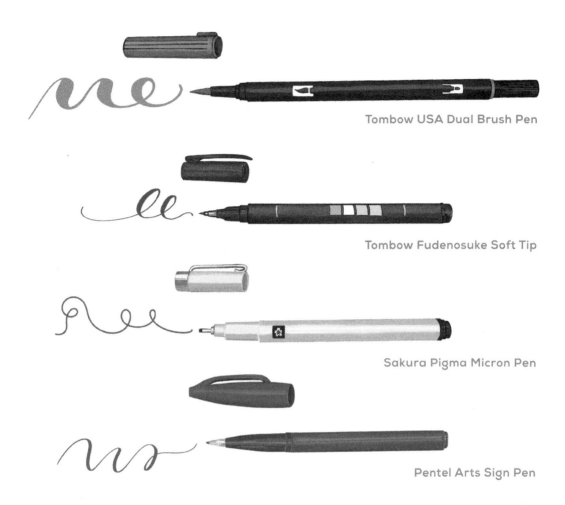

Tombow USA Dual Brush Pen

Tombow Fudenosuke Soft Tip

Sakura Pigma Micron Pen

Pentel Arts Sign Pen

MONOLINE PENS

Monoline pens are used to draw letters that have a consistent weight—that is, there is no variation of thin and thick lines within the letters. My favorite monoline pens are the Sakura Gelly Roll Pen and the Sakura Pigma Micron Pen. Both are beginner-friendly for lettering, and the Gelly Roll Pen is excellent for coloring in small spaces without streaks, which is invaluable if your monoline letters are thick.

PAPER

It's crucial to practice lettering on smooth paper. Using the proper paper will help your brush pen flow evenly and prevent the tip from fraying. Regular printer paper has some grit and roughness to it, and your pen will deteriorate as it's dragged across a rough surface. If you plan to print the additional practice sheets that are included on CallistoMediaBooks.com/easycreativelettering, I recommend using HP Premium32 paper. I also use Rhodia dotPads, which have dot grids, for lettering practice. The dot grid provides a built-in guideline to keep my letters straight. My go-to paper for tracing is marker paper, which has a buttery smooth surface. Tracing paper, which is less expensive, is almost as effective. For card making or finished pieces, try a pad of bristol board.

How to Navigate the Art Store

The endless options available at art supply stores can be intimidating. As a professional artist, I've had nonartist friends frantically call me from the art store asking for help in navigating the fabric paint or Mod Podge. Stores are set up to be wildly colorful and to invite you to explore every possible medium. To avoid panic (and overspending), let's break it down.

Less is more. Start with a single pen in your favorite color. Once you find a pen that you love, buy the full set, and then you'll have two of your favorite color!

Higher quality is worth the price. If you are making art, you are an artist. You're worthy of artist-grade materials. Don't skimp on quality just because you're starting a new hobby. As a beginner, you should invest wisely, purchase only the essentials, and keep an eye out for sales. Don't buy something that is labeled as student-grade quality.

What's available isn't always what you need. If you browse through a store's selection of brush pens and don't recognize any brands or don't like what you see, don't buy anything! Instead, wait until you find a specialty store, or purchase materials online. The stores can't possibly stock everything, so resist the urge to buy the only brush pen on the shelf.

Level up your creative lettering. A few extra supplies will come in handy for future lettering projects. Water brush pens and liquid watercolors are fun for watercolor lettering techniques. I like Pentel Arts Aquash Water Brush pens and Royal Talens Ecoline liquid watercolors. For on-trend chalkboard lettering, consider using chalk markers instead of regular chalk. I prefer Marvy Uchida Bistro Chalk Markers. For lettering on glass, acrylic, or a variety of plastic surfaces, try Molotow ONE4ALL acrylic paint pens.

Don't forget to have some fun at the store! Try out all the pens. Most art supply stores are littered with little pads of paper next to the pen displays. The shops are encouraging you to try out all the pens to figure out what you like!

Setting the Stage

Lettering practice setup is critical to your overall success. Considerations like work space, posture, and how you hold a pen are essential components of developing a productive practice.

CLEAN SPACE, CLEAR MIND

Let's clear some mental barriers to success. Many of my students tell me that they need to create a special or larger work space in order to practice. They also say that they lack the time to clear or prepare this specially dedicated work area. In reality, the size of your work space doesn't determine lettering success. This is a mental block that cuts into practice time. A proper practice space doesn't need to be much larger than the sheet of paper. All you need is a flat surface and a chair (or stool).

Before you sit down to practice, clear your space of clutter. When I sit down, I remove books, my phone, unfinished projects, and other art supplies from my view. If I can see anything beyond what I'm working on, my mind will wander to a different task. A clean space devoid of distractions will help you relax and focus on the work ahead. And yes, this is work! Lettering can be a relaxing meditation and also an exercise of discipline for your creative brain.

POSTURE

Proper posture has a positive effect on your lettering. When you sit up straight, you can breathe deeply, occupy the space around you, and move your arms and fingers more accurately.

When I'm not lettering, I slouch constantly. There's nothing I love more than to curl up on the couch with my journal and doodle while watching TV. Sometimes, I even try to curl up in my uncomfy studio chair. I'll tuck my legs under me and slump over while shopping online.

When I'm practicing lettering, though, my posture is completely different. I sit up straight in my chair, my feet touch the floor, and my upper body leans slightly forward. Try it! You may need to scoot your bottom forward (away from the chair back) to reach an optimal position. Inhale and pull your shoulders back; exhale and relax into a comfortable but attentive position.

HOW TO HOLD YOUR PEN

Pen-holding technique is a little bit controversial—many people believe there's one "right" way to hold a pen. But this isn't necessarily the case. Let's talk about what you should and shouldn't do.

The ideal pen position is at a 45-degree angle. You'll use your thumb and index finger to hold the pen and let the pen rest on your middle finger. It's sometimes called the *three-finger grasp* or the *tripod grip*, and it's taught in elementary schools. This grasp is meant to reduce fatigue.

If you don't typically hold a pen this way, do not panic! You're learning a new skill from scratch. Try out the grip and see if you like it. If it doesn't work for you, hold the pen the way you usually do.

I'm a lefty. I tried using the three-finger grasp and even attempted basic lettering as a righty. Ultimately I settled back into what was most comfortable and worked on my posture instead. My pen grasp is similar to that of a toddler, which is to say—you do you! Don't let an awkward-looking grasp get in the way of your success.

PAPER POSITION

It's vital to position your paper in a way that supports your practice. For instance, if you are creating letters on a 90-degree angle relative to the baseline, you might position your paper at an angle perpendicular to the edge of your desk. If you want to create slanted letterforms using a brush pen, you will need to play around with the angle of your paper, turning it left or right.

The quickest way to find an appropriate angle for your lettering is to take a piece of tracing paper and lay it over a printed practice sheet from this book. Try to trace an underturn stroke on practice page 16 without twisting your wrist. Turn your paper slightly and try again. Keep turning your paper until you can make the mark comfortably.

When trying to find the best angle, don't worry if your pen strokes are squiggly or uneven. Your goal here is to find an angle that will allow you to successfully trace a mark on the page. Making accurate marks will be the next step!

Left-handed writers may find that turning the paper to the right is helpful. Those who are right-handed may prefer turning the paper to the left.

Simple Rules to Follow (to the Letter)

Before we get into lettering practice, there are a couple of important rules. I would rather not say that your success depends on following these rules—but it totally does.

TAKE IT SLOW

Lettering is a slow process. If you're used to digesting media and information quickly, this could be a welcome change of pace. Most lettering videos on social media are sped up. They are meant to capture your attention and provide inspiration. Don't let the speed influence the rate of your lettering practice. If all of my videos were posted at the original speed, some of them would be hours long. Drawing each letter is a slow process. The only thing that will be speedy is your progress. Be sure to date your practice pages so you can go back and see just how quickly you have improved.

Try to digest this book one alphabet at a time. The alphabets may look simple, but if you've ever tried to draw a perfectly straight line, you know it's difficult. Drawing any shape by hand requires practice, so your goal should be to work slowly. Above all, remember it isn't a race. There's no finish line at the end—there's only more to learn!

USE QUALITY MATERIALS

The best materials are often the ones you have, especially if you're on a strict budget. The truth is, though, that low-quality materials will have a negative effect on your practice experience. Low-quality paper will buckle or pill under the weight of inky pens. Low-quality pencils are likely to break more often when you sharpen them. Low-end pens have poor pigment quality, don't last as long, and break more easily.

I used to use an off-brand pen from the dollar store when I practiced. The fibers pulled out from the pen after just a few uses. I know now that my money would have been better spent on a high-quality pen.

PRACTICE, PRACTICE, PRACTICE

If possible, set aside a physical space dedicated to your lettering practice. If you can't do this, keep all of your materials together in a bin near your work space. Set a reminder on your phone to sit down and practice every day. It doesn't matter how long you practice—even 10 minutes will make a difference! Make a schedule to practice different alphabets on different days. Practice variations on letterforms. Do brush calligraphy drills (see page 15) and practice holding your pen in a way that works for you. I draw letters every single day. After you get the hang of lettering, you'll realize that you no longer need to set an appointment with yourself to practice because you'll want to do it all the time! When I go to a restaurant, I leave a personalized hand-lettered thank-you note behind for my server (tip: their name is on the bill).

DON'T STRESS ABOUT PERFECTION

Your end goal is progress, not perfection. Whether I'm sketching on paper or drawing on my iPad, I try to keep simple, measurable goals in mind. This helps me redirect attention away from vague, impossible goals of perfection and toward more achievable goals.

Vague and demoralizing goal: Improve compositions.
Measurable goal: Draw 10 sketches.

Elusive goal: Make letters look more perfect.
Achievable goal: Practice brush calligraphy drills for 10 minutes.

Comparing your previous work to your current work is a great way to stay motivated—I always recommend putting dates on your work so you can observe progress over time. Of course, never compare your work to someone else's. Lettering artists who have spent years refining their skills and techniques are not your competition—you can certainly view their work as aspirational, but don't attempt to make your work look exactly like theirs.

There are many emerging lettering artists on social media. This is the perfect place to find support and inspiration. Social media has opened so many doors for me, and it can do the same for you. You can use this vibrant community to your advantage! Seek out peers and mentors on Instagram to support your creative-lettering journey. Check out hashtags like #lettering, #moderncalligraphy, and #leftylettering (if you're left-handed) as a starting point.

Chapter Two

Step-by-Step Lettering Fundamentals

Let's get you set up for success by going over the foundational rules of creative lettering. In this chapter, we'll review brush lettering fundamentals, tips for monoline lettering, and step-by-step instructions for faux calligraphy. All the tracing exercises within this book should be done with a small brush pen. Reviewing the basics will help with your lettering practice and will set you on the path to proficiently drawing alphabets on your own later.

Brush Lettering Basics

Brush lettering uses a variation of thick and thin lines created with a brush pen. By applying gentle but deliberate pressure with the pen tip, you can create a weighted full downstroke. By releasing pressure and using a featherlight touch, you can create a delicate, thin upstroke. Let's call the thick downward-direction strokes *downstrokes* and the thin upward strokes *upstrokes*. Upstrokes are also called *entrance* or *exit strokes* due to their placement at the beginning or end of a letterform.

The illustrations below show how much pressure you should place on the pen tip and at what angle your pen should touch the paper to create the thick downstroke. Think of the very tip of the pen as being off-limits. Using only the tip will cause it to fray or wear more quickly. Approach the paper at a 45-degree angle and aim for a spot near the tip. Remember, both small and large brush pens are meant to be flexible—don't be afraid to let the tip bend, and don't worry about breaking it.

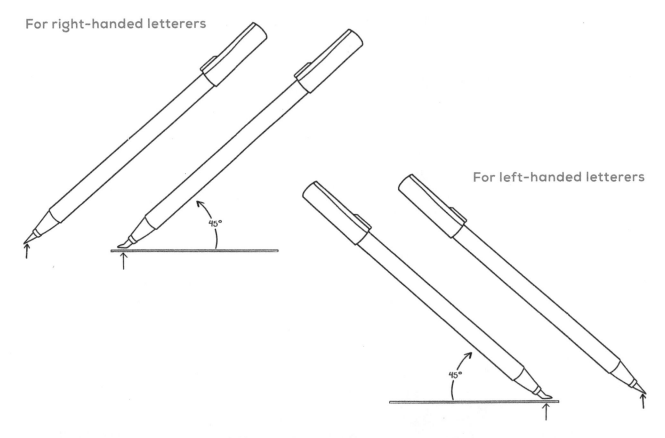

For right-handed letterers

For left-handed letterers

Lefties, this second illustration is for you. That's right, it's a mirror image. Your pen angle is in the opposite direction. You may have figured this out on your own, but I'm providing this illustration to be inclusive and to bust the myth that lefties can't letter!

Here are a few warm-up drills that are designed to familiarize you with applying pressure to a brush pen. Feel free to copy these two pages or place tracing paper on top of them to practice.

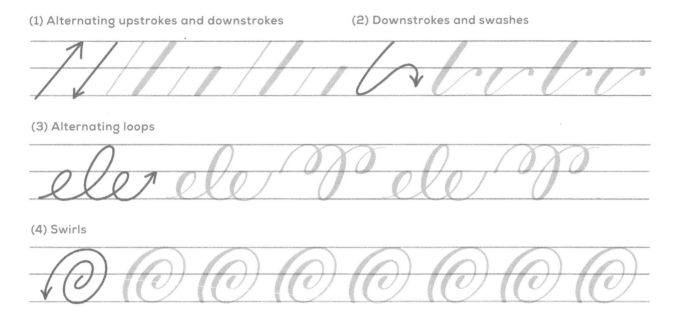

(1) Alternating upstrokes and downstrokes

(2) Downstrokes and swashes

(3) Alternating loops

(4) Swirls

Using the Nine Basic Strokes to Form Letters

Brush calligraphy is simple when you break it down stroke by stroke. Let's be honest—practicing the same strokes over and over again sounds like a lot of tedious work! However, it's the best and quickest way to gain proficiency. You'll find that you keep coming back to this practice to refine your skills. I've been fine-tuning my skills for years, and I still practice my basic strokes.

You won't get very far (with brush calligraphy or faux calligraphy) without practicing basic strokes. The letters are the strokes! Eventually, with enough practice, these strokes will become second nature, and the letters in turn will flow off your brush pen. Until then, don't be discouraged by shaky or oddly spaced practice strokes. Let's look at each of these strokes.

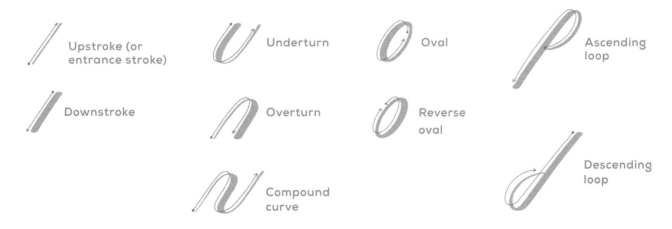

Upstroke (or entrance stroke)

Downstroke

Underturn

Overturn

Compound curve

Oval

Reverse oval

Ascending loop

Descending loop

The next few pages will be dedicated to practicing these nine strokes. Since you'll continue to practice these strokes as you learn to letter, I've provided additional printable practice pages online at CallistoMediaBooks.com/easycreativelettering.

Upstroke: Beginning from the baseline, gently create a thin upward stroke.

Downstroke: Apply pressure to the brush pen as you make contact with the paper. Pull downward from the waistline to the baseline, maintaining consistent pressure.

Underturn: Begin at the waistline. Applying full pressure to the brush pen, pull down toward the baseline. As you approach the baseline, release pressure while curving gently to the right. The transition from a thick stroke to a thin stroke should occur at the baseline. Continue curving gently upward to create the hairline exit stroke.

Overturn: Begin at the baseline. Create a thin upward stroke toward the waistline. As you approach the waistline, begin to curve gently to the right, creating an arch at the waistline. As you exit the arch, slowly begin to apply full pressure. The transition from a thin stroke to a thick stroke should occur at the waistline. Continue pulling downward to the baseline while applying full pressure.

Compound curve: This stroke is a combination of an overturn and an underturn with alternating hairline and full pressure strokes. Start with the strokes that make up an overturn, but instead of ending on the thick stroke, create an underturn and bring a hairline stroke back up to the waistline.

Oval: You'll draw these going counterclockwise. Always start at the 1 o'clock position, just below the waistline. Begin the oval form with a hairline stroke and quickly apply pressure on the left side of the form to create a thick stroke, moving counterclockwise. As you approach the baseline, release pressure and curve back upward with a thin hairline stroke to enclose the oval where you began.

Reverse oval: This form is the exact opposite of the oval form—you'll draw these going clockwise. The full pressure side of this form will be on the right instead of the left. Always start at the 11 o'clock position, just below the waistline. Begin the reverse oval form with a hairline stroke and quickly add pressure to create a thick downward stroke on the right side, moving clockwise. Curve back up and enclose the reverse oval with a hairline stroke.

Ascending loop: Begin at the waistline and draw a curved hairline stroke up toward the ascender line. As you approach the ascender line, curve toward the left to form a loop. At the ascender line, slowly transition to a full pressure stroke and pull downward to the baseline.

Descending loop: Begin at the ascender line and pull downward with a full pressure stroke. As you approach the descender line, curve toward the left to form a loop. At the descender line, slowly transition to a hairline stroke. Close the loop at the baseline.

FORMING LETTERS

The nine basic strokes are used to form an entire script brush-calligraphy alphabet. The lowercase alphabet, save for a few specific strokes (in gray), can be made using these basic strokes!

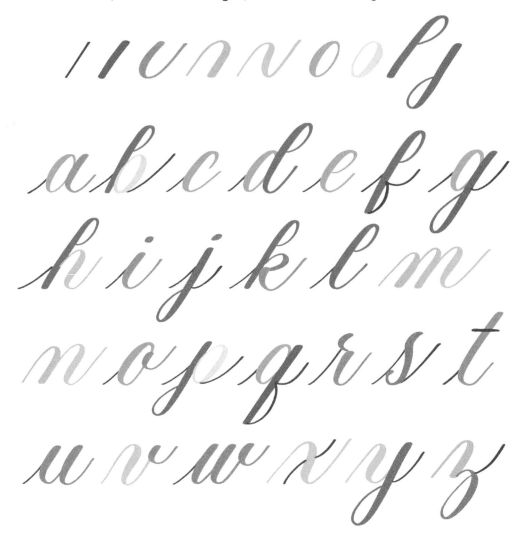

Let's look at a few examples to see how easy it is to create letters from strokes.

| Overturn + compound curve = n | Upstroke + underturn = i | Upstroke + descending loop + upstroke = j | Upstroke + ascending loop + reverse oval + upstroke = b | Upstroke + oval + downstroke + upstroke = q |

You can see that some of the letters are made up of four strokes. When you practice, try forming letters with their entrance and exit strokes. You'll need this skill to understand what comes next: connecting letters!

Try connecting some strokes to make letters here.

n n

i i

j j

b b

q q

How to Join Letters

It's essential to practice connecting—or joining—letters so you can form words. It might feel artful or edgy to have inconsistent, uneven lettering, but you still need to make sure your letters are legible.

 If you've practiced making letters with entrance and exit strokes, congratulations! You're halfway there. The second half of mastering letter joining is getting those entrance and exit strokes to match up and connect. For some letters, it's simple:

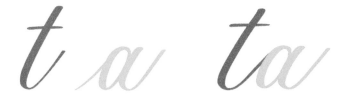

Nudge the lowercase *a* to connect to the exit stroke of the *t*. Trace the samples below to practice this simple letter connection.

In the basic strokes practice pages you learned to create a compound curve. To join some letters together smoothly and effectively you will need to sometimes use a reverse compound curve.

Overturn + underturn = compound curve Underturn + overturn = reverse compound curve

By drawing the letters next to one another, you can see how to connect them, even if one has a tricky entrance stroke (like an *n*).

If you move the *n* closer to the *i*, you'll see that an underturn + overturn drawn together in one stroke will give you the word *in*. Joining these letters uses a reverse compound curve. Try it and practice this combination.

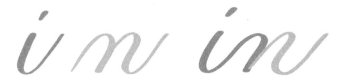

Try this method again for letters that have an awkward or tricky exit stroke, like the *o*.

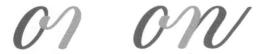

The exit stroke of the letter *o* is a tiny underturn. For most letter connections from the *o*, you can use the exit upstroke of the underturn as an entrance stroke to the next letter.

 There are some exceptions: If the letter after the *o* is an *n*, *m*, *v*, or *w*, you'll need a different exit stroke. To create a letter connection from *o* to *n*, change that underturn into a shortened reverse compound curve. Here are a few more combinations for you to practice.

When in doubt, write the two letters next to each other and see where they logically fit together. With practice, you'll start to be able to connect letters effortlessly.

Don't Get Left Behind: Tips for Lefties

Left-handed friends: You, too, can create beautiful brush calligraphy letters! Lefties often get lost in the shuffle of this lettering game. Brush calligraphy scripts, in particular, can be tricky for lefties. But I'm a lefty, and I'm here to help with a short list of tips to keep you feeling motivated.

Paper and seating position: When positioning your paper, try to turn it the same way you usually would, but be open to rotating it even farther. I turn my body 45 degrees to the right, so my left hip is against my desk. From there, I adjust the angle of my paper until I'm able to comfortably trace a line of basic practice strokes.

Smudges and smears: Have patience. Wait for ink to dry before you complete a word. Use the waiting time as an opportunity to slow down and concentrate on every stroke. When lettering with a pencil, try placing scrap paper under your left hand to avoid smudging your work. If you've outlined an entire lettering piece in pencil, trace it in ink from right to left to prevent smearing.

Push versus pull: As a lefty, you'll push the pen with your hand rather than pulling it. Take extra time to practice drawing upstrokes—since you're pushing the pen, it can be tricky to make a tiny line. When drawing overturn strokes, try not to bend your wrist. Keep your wrist straight as you make strokes; never twist or change your position just to make one stroke.

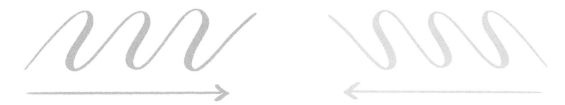

Here's a simple exercise that will help lefties feel the difference between writing righty and lefty. Copy this page or place a piece of tracing paper over it. Trace the wavy stroke on the left with your left hand going forward and pushing the pen. Use pressure on the downstrokes. This is how you'll push the pen across the page when lettering with a brush pen. Now, trace the wavy stroke on the right, but instead of going left to right, try it right to left. Feel how you're pulling the pen rather than pushing it.

As a lefty, you should find the second stroke more comfortable—that is, it should be easier to go backward. This is how righties pull the pen. Once you understand the difference, you will be able to adapt and make changes to your position, however you grip the pen. If you're discouraged, practice more ovals! The oval form should be easier for you than for a righty, since you're pulling the oval around and back toward your hand.

Lefty supplies: Some lefties swear by "quick-dry" pens. I don't see a huge difference in supplies, but it never hurts to try something out! When you begin to practice, buy a couple of brush pens, but don't get too attached to them—you may find that the pen you prefer isn't the one you expected. Practice with only one or two pens until you get the hang of all the differences.

Faux Calligraphy Basics

Faux is a French word that means "false." Faux calligraphy is a style of lettering that uses a round pen to mimic the appearance of brush pen calligraphy. This style is especially useful when lettering a large mural or chalkboard in a brush script. You can't use a brush pen on every surface, especially for larger pieces, so faux calligraphy comes in handy.

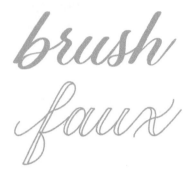

The brush calligraphy sample on the top left features thin upstrokes and thick downstrokes with consistent weights.

On the bottom, a well-executed example of faux calligraphy has nearly the same appearance. The upstrokes are created with a monoline pen, and the "thick" downstrokes are carefully drawn in. If the downstrokes in this faux calligraphy example were filled in, it would be difficult to tell the difference between faux and brush calligraphy.

You can learn faux calligraphy by following these three quick steps:

1. Draw with a monoline pen. You'll use the same basic strokes you learned earlier in this chapter to create these letters.

2. Add weight to the downstrokes by drawing additional lines to the right of each letter.

3. Color the space in between the lines to give the appearance of weight.

Here are two words you can use to practice faux calligraphy. Follow the three basic steps, and you'll be a master faux calligrapher in no time!

find balance

Here's another fun variation I like to use when practicing faux calligraphy: Draw your faux calligraphy in pencil, erase any overlapping marks, and ink over letterforms with a monoline pen.

focus

FAUX CALLIGRAPHY TIPS FOR LEFTIES

When attempting faux calligraphy as a lefty, you may find your letterforms appear too close together or too far apart. This illustration may help explain why.

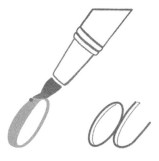

The dot indicates where the pen hits the paper for a righty—the outside edge of the oval. That means the faux marks for a righty are always on the right.

The dot indicates where the tip of the pen hits the paper for a lefty—the inside edge of the oval. As a result, adding weight to the right side of letters may cause letters to appear crowded.

To avoid crowded-looking letterforms, add weight to the left side of your letters instead of the right side. To ensure your letters are evenly spaced and to avoid overlap, try leaving extra space between the downstroke lines for the downstroke "swell" (for example, between *m* and *i*). My own faux calligraphy comes out more evenly spaced when I allot this extra space in between.

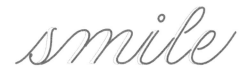

Troubleshooting Common Lettering Mistakes

I often ask my community of friends on Instagram for their most common lettering mistakes, concerns, and problems. The following questions are by far the most frequently asked.

Q: My brush pen is already worn out and frayed. Is this normal?

A: You are either not writing at a 45-degree angle or not using smooth paper for practice. A brush pen will wear out and fray, but that takes a while. This isn't something that happens after a week. See my paper recommendations on page 7.

Q: How do I create more variation between my thin and thick strokes? Mine look very similar.

A: As long as you are working on the motion of applying heavier pressure when making a downstroke compared to an upstroke, you are working in the right direction. Date your practice sheets so you can compare your strokes week after week. My own stroke variation has changed wildly from almost equal in weight to too thin and too thick. It was like I was trying to prove something by having the lightest possible strokes and contrasting them with the thickest strokes my pen could produce. I assure you, your variation will improve with time and practice. Focus on putting weight in the proper place.

Q: How do I make my upstrokes smooth? My thin strokes appear very shaky.

A: You are working with a felt-tipped marker that has a flexible tip. You're probably not used to putting a pen down on paper with varying amounts of pressure. Learning to draw a thin line takes about two seconds. Making it straight and even and smooth requires time and control. With practice, your strokes will become less shaky. The good thing about upstrokes is that they don't take up a lot of space. You can fit hundreds of them onto your practice sheet.

Q: Why do some people write using slanted guidelines?

A: Many people practice lettering with slanted guidelines (called *slant lines*) drawn on a grid at a 55-degree angle. These guidelines are used to ensure brush script letterforms are aligned and consistent. Letters that don't line up result in words that look like they are swaying in the breeze at different angles. You want to learn the rules before you begin breaking them. Pick an angle and use it to line up your lettering. The angle can be 90 degrees—it doesn't need to be slanted.

The first letter *y* is shown in alignment with the 55-degree guideline. The second *y* is out of alignment.

The word *hey* is shown in alignment on a 55-degree slant. *Love* is shown at an almost upright angle, closer to 90 degrees.

Handy Tips for Monoline Lettering

The only real rule of monoline lettering is that it is made up of lines with no variation in weight. Monoline lettering is often done with a single stroke of a monoline round-tip pen. Monoline letters are also the basis of faux calligraphy. You can create script, serif, and sans serif letters using the monoline style.

script SERIF SANS SERIF

When it comes to drawing monoline letters, there isn't an enormous learning curve. As long as you work slowly and use a pen that has a round tip, doodling monoline letters can be very relaxing. With that said, it's not easy drawing a straight line, so I would never call monoline sans serif boring or *easy*! We'll practice sample monoline alphabets in chapter 4, but here are a few tips for designing your own serif- and sans serif–style letters.

1. Practice drawing lines and shapes. Letterforms can be broken down into basic shapes. Practice drawing simple shapes and lines until you are confident and steady-handed.

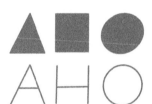

Letters like *A* and *V* are made with triangles. *H* and *L* are made with squares. *O* and *Q* are made with circles.

2. Use a box grid. Draw a box grid with a 2:1 ratio (twice as tall as it is wide) or trace the one below. Try out different monoline letter styles by drawing shapes within the box.

3. If you'd like, add dots or serifs to the ends of your strokes for interest. Doing this can add movement to your letterforms.

dots serif

Part TWO

The ABCs of Lettering

Don't practice until you get it right. Practice until you can't get it wrong.

Chapter Three
Script Alphabets

Now that you're familiar with the fundamentals of letter formation, let's try out some script alphabets. In this chapter, we'll review five different styles of script alphabets. Three of them are intended for small brush pens, and two are a faux calligraphy style. You can practice the last two using a monoline pen (see my recommendations on page 7). To practice each script style, place a piece of tracing paper over the full alphabet example page to practice. There are five additional practice pages for each script style, with room for both tracing and practice. You can find additional printable practice pages online at CallistoMediaBooks.com /easycreativelettering.

Magnolia

This alphabet is the most formal script that we will practice. It is set on a 55-degree slant line and should be drawn with a brush pen. It can be dressed up even further with flourishes (see page 98). This elegant script is perfect for wedding invitations or formal dinner-party place cards.

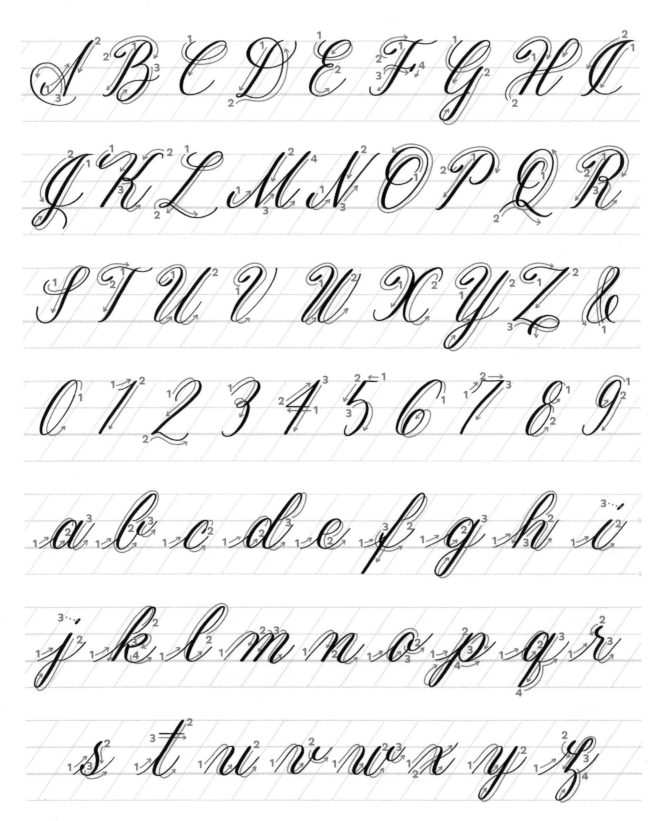

Trace twice before trying on your own.

$\mathcal{A} \mathcal{A} \mathcal{A}$ $a\,a$

$\mathcal{B} \mathcal{B}$ $b\,b$

$\mathcal{C} \mathcal{C}$ $c\,c$

$\mathcal{D} \mathcal{D}$ $d\,d$

$\mathcal{E} \mathcal{E}$ $e\,e$

$\mathcal{F} \mathcal{F}$ $f\,f$

$\mathcal{G} \mathcal{G}$ $g\,g$

Hh Hh hh

Ii Ii ii

Jj Jj jj

Kk Kk kk

Ll Ll ll

Mm Mm mm

Nn Nn nn

O O o o

P P p p

Q Q q q

R R r r

S S s s

T T t t

U U u u

V V *v v*

W W *w w*

X X *x x*

Y Y *y y*

Z Z *z z*

0 0 *1 1*

2 2 *3 3*

4 4 5 5

6 6 7 7

8 8 9 9

& &

VARIATION TIP

Increase the cap height by about another ⅓ inch. Adjusting the ratio of letterforms to one another is a relatively simple modification that can have a huge impact.

Dream

Foxtail Palm

This alphabet is a simplified informal script. It is set on a 55-degree slant line and drawn with a brush pen. Since it's written on an angle, this alphabet maintains a sense of decorum but without any fussy flourishes. This bold and versatile script is ideal for a luncheon menu, informal party invitations, or greeting cards.

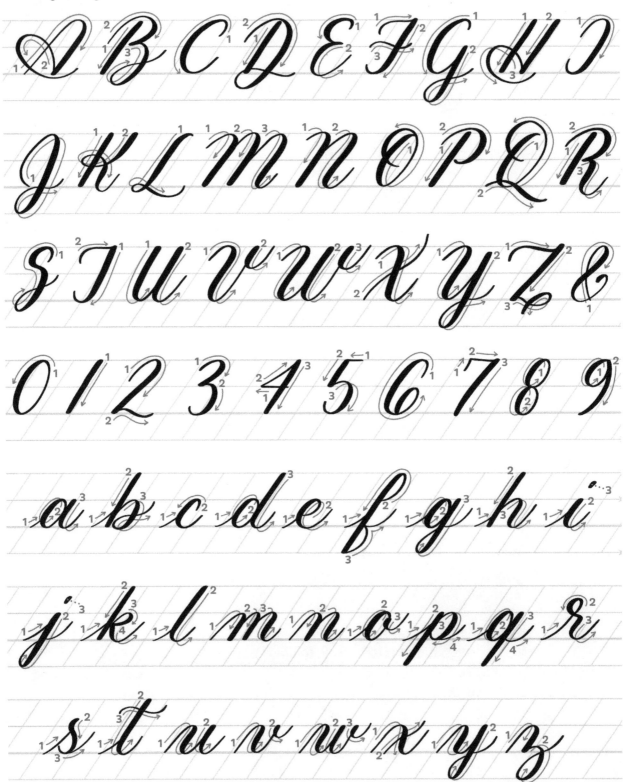

Trace twice before trying on your own.

$\mathcal{A}\,\mathcal{A}\,\mathcal{A}$ $a\,a$

$\mathcal{B}\,\mathcal{B}$ $b\,b$

$\mathcal{C}\,\mathcal{C}$ $c\,c$

$\mathcal{D}\,\mathcal{D}$ $d\,d$

$\mathcal{E}\,\mathcal{E}$ $e\,e$

$\mathcal{F}\,\mathcal{F}$ $f\,f$

$\mathcal{G}\,\mathcal{G}$ $g\,g$

$\mathcal{H}\,\mathcal{H}$ $h\,h$

$\mathcal{I}\,\mathcal{I}$ $i\,i$

$\mathcal{J}\,\mathcal{J}$ $j\,j$

$\mathcal{K}\,\mathcal{K}$ $k\,k$

$\mathcal{L}\,\mathcal{L}$ $l\,l$

$\mathcal{M}\,\mathcal{M}$ $m\,m$

$\mathcal{N}\,\mathcal{N}$ $n\,n$

O O o o

P P p p

Q Q q q

R R r r

S S s s

T T t t

U U u u

𝒱 𝒱 𝓋 𝓋

𝒲 𝒲 𝓌 𝓌

𝒳 𝒳 𝓍 𝓍

𝒴 𝒴 𝓎 𝓎

𝒵 𝒵 𝓏 𝓏

0 0 1 1

2 2 3 3

4 4 5 5

6 6 7 7

8 8 9 9

& &

Sea Grape

This alphabet is a modern variation on a brush calligraphy script. It is the least formal of the brush-pen script alphabets in this book. The hallmark of this bold, funky script is its heavy-handed downstroke. This script will stand out on chalkboard designs and birthday cards.

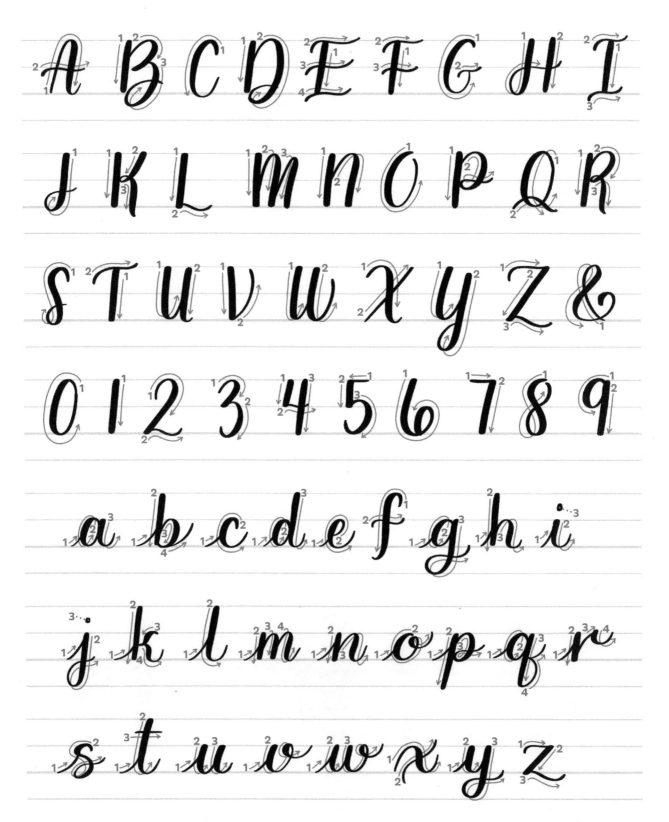

Trace twice before trying on your own.

A A a a

B B b b

C C c c

D D d d

E E e e

F F f f

G G g g

H H h h

I I i i

J J j j

K K k k

L L l l

M M m m

N N n n

O O o o

p p p p

Q Q q q

R R r r

S S s s

T T t t

U U u u

V V v v

W W w w

X X x x

Y Y y y

Z Z z z

0 0 1 1

2 2 3 3

4 4 5 5

6 6 7 7

8 8 9 9

& &

VARIATION TIP

For a whimsical look, increase the length of connecting strokes.

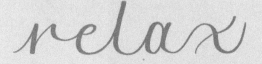

Hibiscus

This formal but fun faux calligraphy alphabet mimics the look of a brush pen script. Remember to add weight to the downstrokes by drawing additional lines to the right of each letter. This alphabet is suitable for lettering with a monoline pen on large lettering projects where you can't use a traditional brush pen. It is ideal for chalkboards and wooden signs.

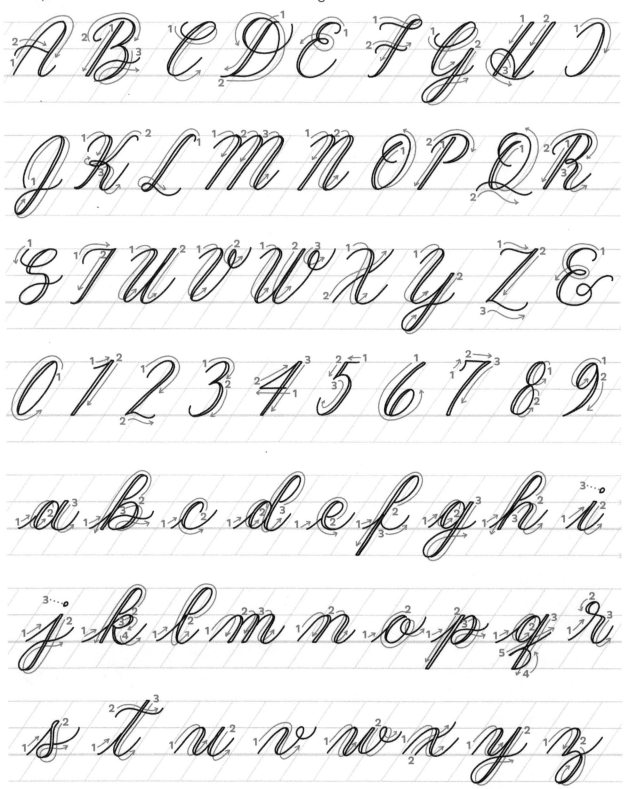

Trace twice before trying on your own.

A A a a

B B b b

C C c c

D D d d

E E e e

F F f f

G G g g

H H k k

D D i i

J J j j

K K k k

L L l l

M M m m

N N n n

O O o o

P P p p

Q Q q q

R R r r

S S s s

T T t t

U U u u

𝒱 𝒱　　　𝓋 𝓋

𝒲 𝒲　　　𝓌 𝓌

𝒳 𝒳　　　𝓍 𝓍

𝒴 𝒴　　　𝓎 𝓎

𝒵 𝒵　　　𝓏 𝓏

0 0　　　1 1

2 2　　　3 3

4 4 5 5

6 6 7 7

8 8 9 9

& &

Mangrove

This whimsical faux calligraphy alphabet re-creates the appearance of a brush pen script using a monoline pen. Add weight to the downstrokes by drawing additional lines to the right of each letter. This script is useful for lettering on surfaces that won't accept a brush pen. It's perfect for lettering seating charts on acrylic panels or mirrors, or large-scale script murals.

Trace twice before trying on your own.

A A a a

B B b b

C C c c

D D d d

E E e e

F F f f

G G g g

H H h h

I I i i

J J j j

K K k k

L L l l

M M m m

N N n n

O O o o

P P p p

Q Q q q

R R r r

S S s s

T T t t

U U u u

V V v v

W W w w

X X x x

Y Y y y

Z Z z z

0 0 l l

2 2 3 3

4 4 5 5

6 6 7 7

8 8 9 9

& &

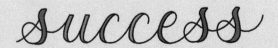

I CRAFT
so hard
I SWEAT
glitter

Chapter Four
Serif and Sans Serif Alphabets

Now that you have practiced a variety of script alphabets, let's take a look at serif and sans serif alphabets. You can use tracing paper on top of every alphabet sample page to practice the style, and additional practice pages will follow for each lowercase letter, uppercase letter, and number.

This chapter includes two serif alphabets and three sans serif alphabets. One of the sans serif alphabets is drawn with a brush pen, and the other two sans serif alphabets use a monoline pen. You will practice the sample alphabet on the grid and try to create your own monospace alphabet (an alphabet in which each letter is created with equal width) on a blank grid provided. You can find additional printable practice pages online at CallistoMediaBooks.com /easycreativelettering.

Tortuga

This serif alphabet is created using a monoline pen. Start by drawing a single stroke. Then, add weight to the strokes by drawing a second stroke just to the right. Fill in any space in between. You can also use a larger marker to create the same style with a single stroke. This lettering style creates beautifully bold envelopes, thank-you cards, and gift tags.

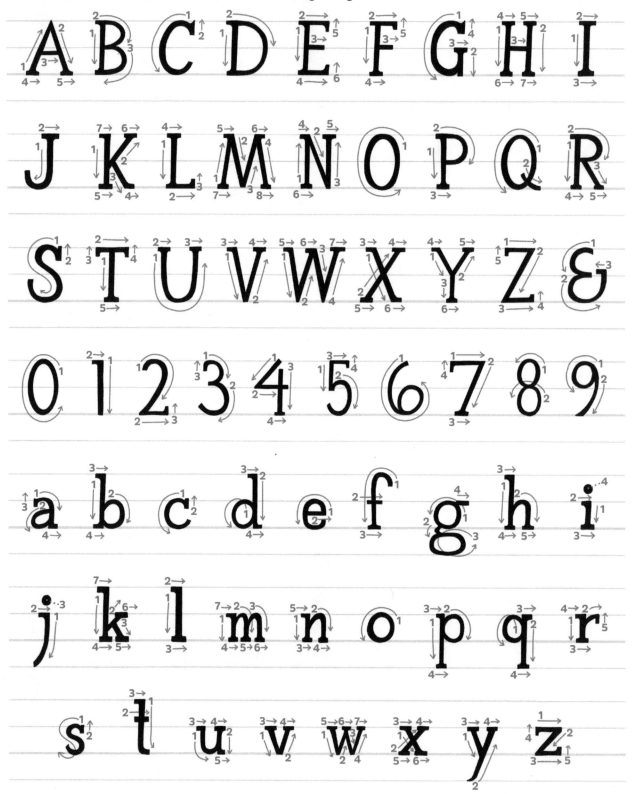

Trace twice before trying on your own.

A A a a

B B b b

C C c c

D D d d

E E e e

F F f f

G G g g

H H h h

I I i i

J J j j

K K k k

L L l l

M M m m

N N n n

O O o o

P P p p

Q Q q q

R R r r

S S s s

T T t t

U U u u

V V v v

W W w w

X X x x

Y Y y y

Z Z z z

0 0 1 1

2 2 3 3

4 4

5 5

6 6

7 7

8 8

9 9

& &

VARIATION TIP

Try drawing this alphabet with a pencil first and inking over with a small monoline pen to create an outline-only look for your designs.

Cypress

This serif-style alphabet is created with a monoline pen and uses a similar technique to the faux calligraphy script alphabets. Draw the initial letterform with a small pen, then go back to create the thicker contrasting downstrokes. This alphabet is perfect for use in monogramming and other personalized stationery projects.

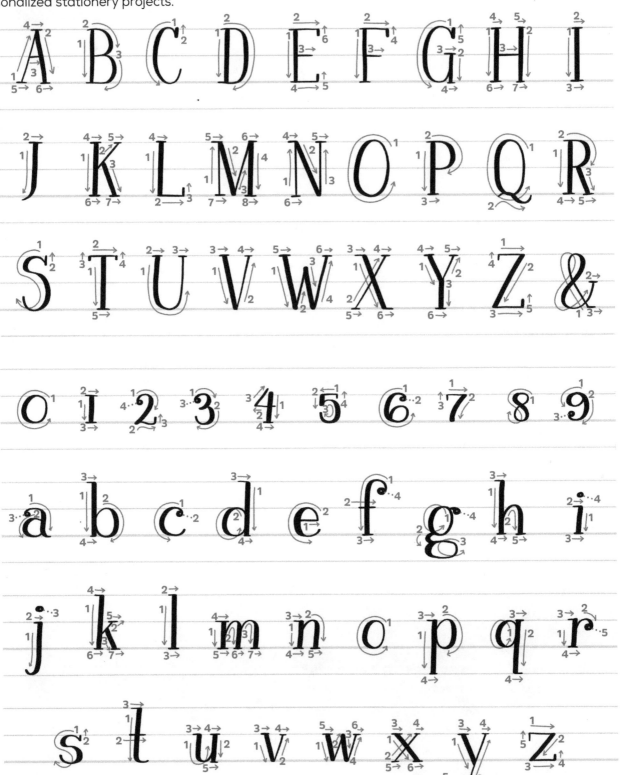

Trace twice before trying on your own.

A A a a

B B b b

C C c c

D D d d

E E e e

F F f f

G G g g

H H h h

I I i i

J J j j

K K k k

L L l l

M M m m

N N n n

O O o o

P P p p

Q Q q q

R R r r

S S s s

T T t t

U U u u

V V v v

W W w w

X X x x

Y Y y y

Z Z z z

0 0 1 1

2 2 3 3

4 4 5 5

6 6 7 7

8 8 9 9

& &

Starfish

This sans serif alphabet is drawn with a brush pen. It is a lively style that pairs well with other brush script alphabets. As with brush scripts, the letterforms in this alphabet have contrasting thick and thin weights, formed using hairline and full pressure strokes. This casual alphabet is perfect for journaling, scrapbooking, and decorating gift wrap.

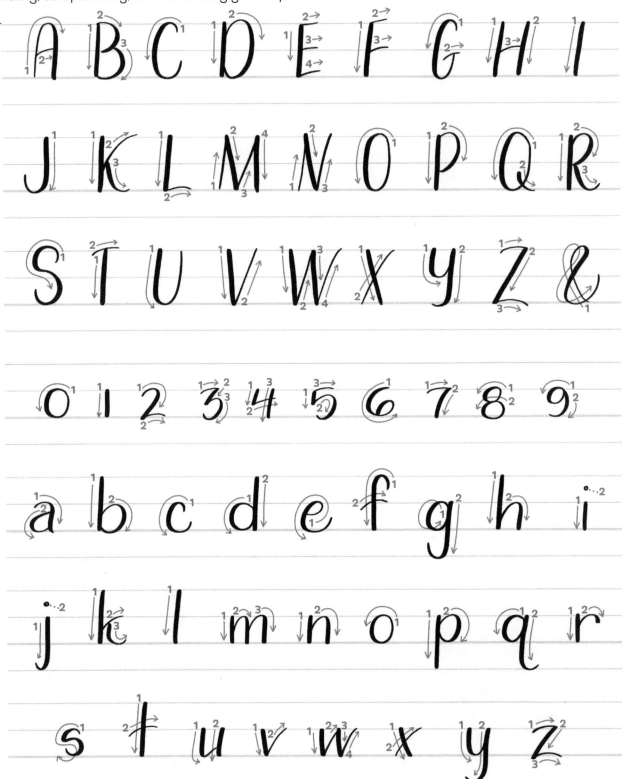

Trace twice before trying on your own.

A A a a

B B b b

C C c c

D D d d

E E e e

F F f f

G G g g

H H h h

I I i i

J J j j

K K k k

L L l l

M M m m

N N n n

O O o o

P P p p

Q Q q q

R R r r

S S s s

T T t t

U U u u

V V v v

W W w w

X X x x

y y y y

Z Z z z

0 0 1 1

2 2 3 3

4 4 5 5

6 6 7 7

8 8 9 9

& &

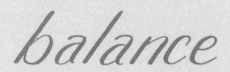

balance

Chica

This sans serif alphabet is drawn in a monoline style. It is a simple but highly decorative style that can be altered to great effect by changing the width of each letterform. Draw each letterform using a single stroke and then go back to add the secondary strokes to the right. This straightforward geometric alphabet is ideal for craft projects like mugs and tote bags.

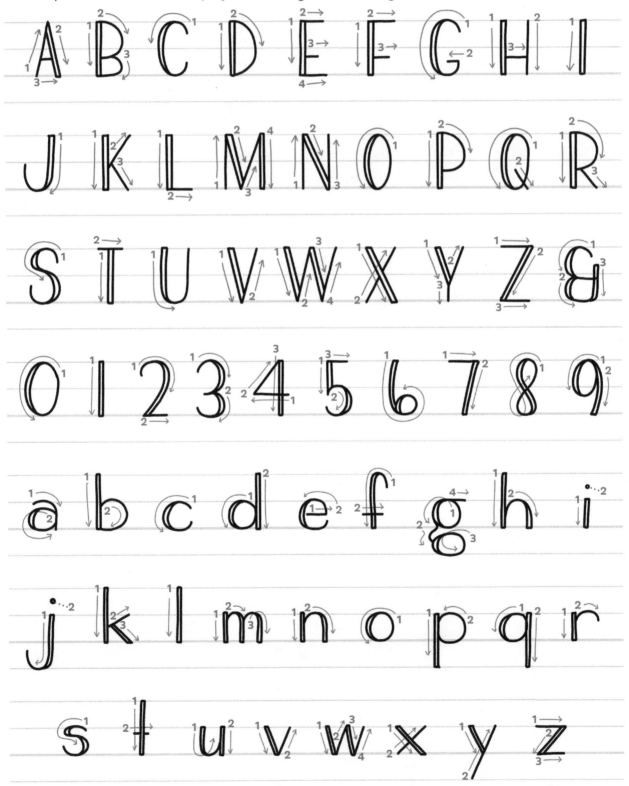

Trace twice before trying on your own.

A A a a

B B b b

C C c c

D D d d

E E e e

F F f f

G G g g

O O o o

P P p p

Q Q q q

R R r r

S S s s

T T t t

U U u u

V V v v

W W w w

X X x x

Y Y y y

Z Z z z

O O | |

2 2 3 3

44 55

6 6 77

8 8 9 9

8 8

Sawgrass

This sans serif alphabet is drawn in a monoline and monospaced style, which means that all the letterforms take up the same width. Alphabets in this style are ideal for banners and children's projects. Monospaced alphabets are often used when lettering needs to be aligned for legibility. Practicing this alphabet on a single box grid is a great exercise to introduce you to creating your *own alphabet* for the first time. On the pages that follow, you'll practice tracing this sample alphabet. You'll then use the additional space provided to design your own monospaced alphabet.

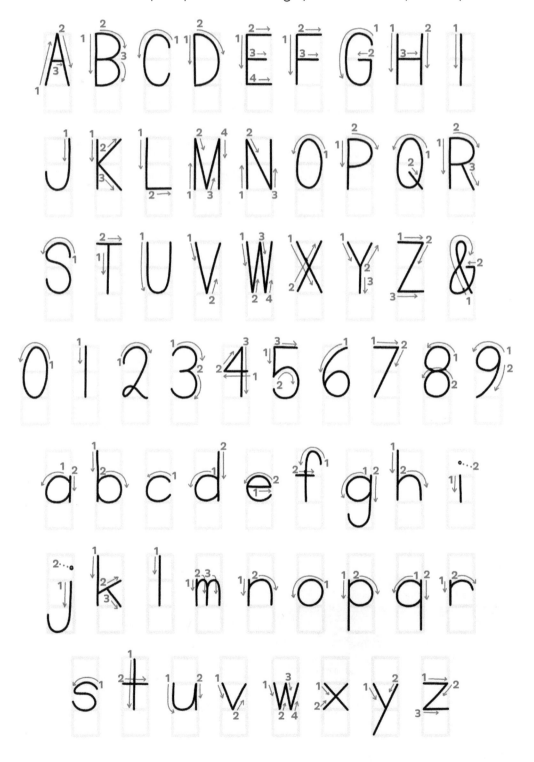

Trace the sample uppercase alphabet and numbers within the monospace grid.

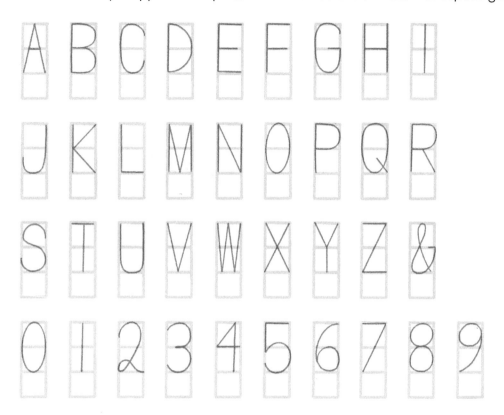

Try drawing the uppercase alphabet and numbers on your own.

Trace the sample lowercase alphabet within the monospace grid.

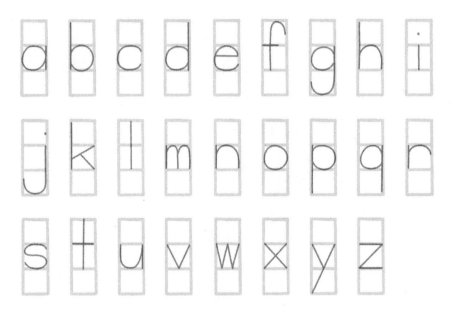

Try drawing the lowercase alphabet on your own.

Now trace the sample capital letters and numbers and add contrasting stroke weight or serifs.

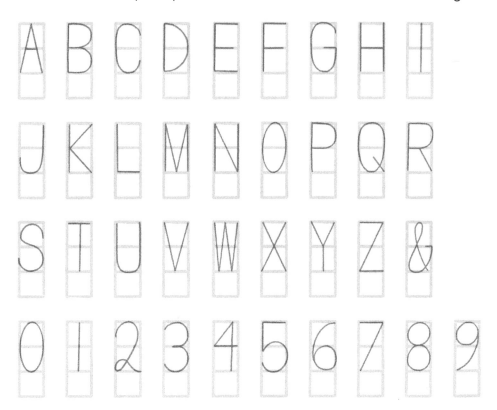

Draw your own monospaced capital letters and numbers in any style you prefer.

Now trace the sample lowercase letters and add contrasting stroke weights or serifs.

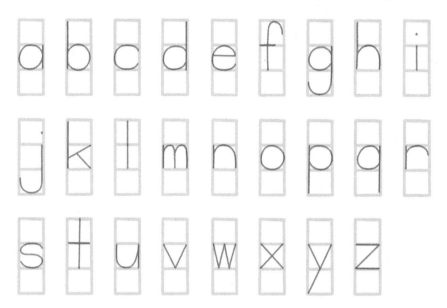

Draw your own monospaced lowercase letters in any style you prefer.

VARIATION TIP

Spice up your own variations by contrasting stroke weights or adding serifs.

goals goals

you get

ght. wron

ce until

an't get

Part THREE

Go Forth and Create

til you right.

actice

can't

Chapter Five

Adding Creative Elements

Now that we've covered the basics, let's go over some easy techniques to instantly level up your lettering game. In this chapter, we'll look at adding all the extra touches to give your lettering some personality, review how to combine styles, and introduce you to the art of creating your own simple lettering composition. It's time to get creative!

Fun Flourishes

Adding an extra dimension to your letters is simple—use a flourish! Flourishes are ornamental flowing lines that add interest and balance to lettering compositions. If you ever miscalculate the width of an envelope or card and your lettering isn't entirely centered, you can fix it by adding a flourish.

When I began lettering, I refused to try flourishing. It looked both elegant and intimidating! I didn't feel skilled enough to know the difference between a polished flourish and a meandering mess of swirls. After working hard to perfect my letterforms, the last thing I wanted was to make a scribbled mess of my work with a botched flourish. My solution was to start with simplified flourishes and slowly build up to more complex ones. I chose a couple embellishments to work on and incorporated them into my daily practice.

Knowing where to add flourishes will be key to your success. Some natural places to add flourishes are at the entrance stroke of the first letter and the exit stroke of the last letter. Below are six examples of two words flourished in different ways. Another great place to add flourishes is off ascenders and descenders—notice the *l*, *h*, and *y* in the examples that follow.

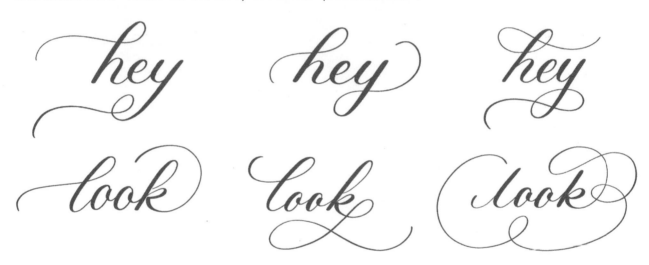

As you can see, I've added a couple of different flourishes to the entrance stroke of the first letter and the exit stroke of the last letter. Sometimes the flourishes sit above the baseline, and sometimes they travel below the baseline. You can also draw in ornate embellishments off the exit stroke of the final letter that encircle the word.

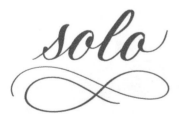

You can also add a flourish on its own under the word or in between words. These flourishes don't need to be attached to a letterform—they can hang solo.

How do you know if you're going overboard with flourishes? A skillfully flourished word will look balanced. Let's look at these two examples of the word *love*.

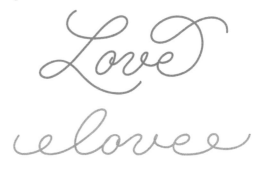

The word *love* on the top is well-balanced. There is symmetry with flourishing at the beginning and the end of the word. You don't need perfect symmetry for a successful design, but in this example, it works well.

The word *love* on the bottom is not a successful design. The flourishes on the left and the right align along the baseline, making the word illegible (it looks like it says "elovee"). Be wary of curlicue flourishes that may disguise themselves as extra *e*'s or *y*'s.

Flourishes also work with serif and sans serif lettering. One common flourish for these letters, called a *swash*, is an extension of a serif or sans serif letter. Swashes are an effective way to bring a design to life because they can add movement to a static design.

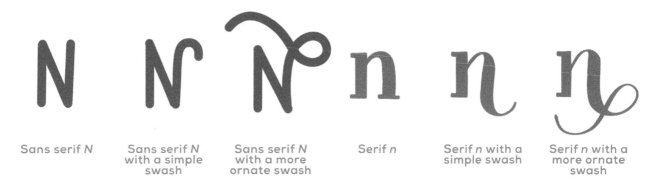

| Sans serif *N* | Sans serif *N* with a simple swash | Sans serif *N* with a more ornate swash | Serif *n* | Serif *n* with a simple swash | Serif *n* with a more ornate swash |

There are a lot of ways to create swashes on serif and sans serif letters. Trace the examples below.

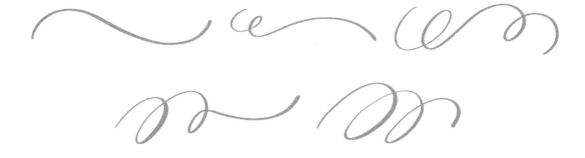

Now try flourishing using a brush pen. Take a look at these examples and trace them. All of these flourishes would work either as fanciful exit strokes or on their own. Note that all of these should be drawn from left to right.

Let's try practicing some flourishes that are attached to letters. You can choose either to use these flourishes as they are or to build up to more complex flourishes. Practice any way you prefer. Trace directly over the examples in this book or use tracing paper and practice your own flourishes.

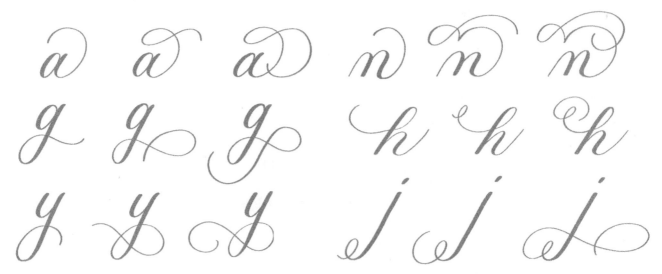

Easy Embellishments

Another way to add dimension if you have space, is to add illustrative elements around your letters, like floral wreaths, banners, botanical line drawings, or icons. If you have limited space or if you prefer a more straightforward design, consider using highlights, drop shadows, or bubble outlines on your lettering. To avoid a design that is too busy, use one embellishment at a time.

A floral wreath makes a beautiful addition to a chalkboard project, a card, or a framed print. This example shows how you can quickly build a wreath with just a couple of simple doodles. Practice drawing the leaves, then try the flowers. I've included guides that show how to draw them from multiple views (bottom, side, and top) to add variety.

To make a wreath, you'll start with a circle. Arrange your flower and leaf illustrations around the circle to create a wreath. Draw a circular shape as your base and add leaves and flowers to create your own design. Remember, the flowers don't need to be intricately detailed or perfect—balance in the overall design should be your ultimate goal.

Practice drawing simple leaves

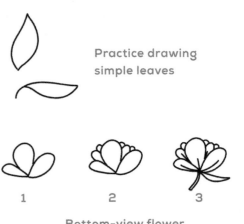

Bottom-view flower

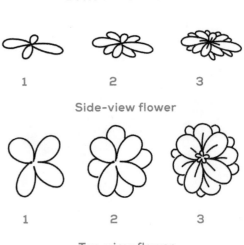

Side-view flower

Top-view flower

The examples below show a wreath with flowers going all the way around and a wreath with only a few flowers framing the lettering.

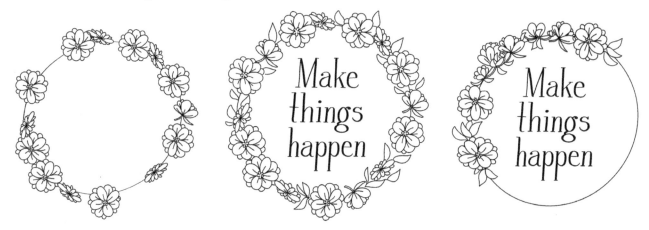

A banner is another element that makes lettering stand out. This example uses sans serif styles, but you can also use script lettering. Banners with sharp angles are direct and exclamatory. Banners that flow and have a curved baseline are ideal for carefree and laid-back designs.

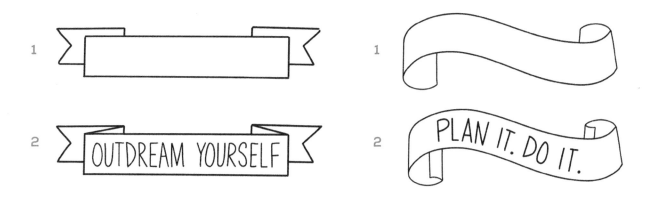

Botanical line drawings can frame your work for dramatic effect. In this design, a basic sketch of waving fern leaves illustrates the breezy nature of this lettering sample.

Icons like arrows or motion lines can both show direction and place emphasis on certain words. Trace the samples below. Then try adding these elements to your own lettering.

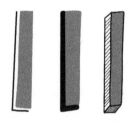

Highlights are useful when you have limited space or when you'd like to add some visual dimension to your lettering. These are useful on envelopes or for headers that need to stand out, such as the title of a poem or the first line of an invitation. To achieve this effect, use a black brush pen for the thick downward stroke. Then add the varying dot-and-dashed highlight patterns using a white or a colored gel pen that is visible on top of black ink. Try out an effect or embellishment on a single stroke before you continue with the whole word. Does it look good on a single stroke? Great! It will likely look good on the rest.

Here's a lettering piece written using the same highlight pattern. For consistency, use the same highlight pattern on every downstroke in the word.

Drop shadows will make your lettering jump off the page! If you draw them carefully and accurately, you can use drop shadows to create a lifelike three-dimensional look. Try redrawing the examples to the left, and imagine you're drawing a box or a sphere. Perspective lines and shading can get detailed, but with these techniques, you can create simple, sleek 3D designs.

Here is an entire word drawn using a drop shadow. As you can see, the simple use of this style adds more dimension.

Outlining is another technique that can instantly elevate your lettering. Carefully draw a border around your letters. Do your best to keep the spacing in between the outlining and the letterforms consistent. Try tracing the example to the right.

Mix and Match Styles

A third way to add dimension to your lettering work is to mix and match styles. Test out the following tried-and-true combinations before exploring others on your own. Here are a few examples that work well together.

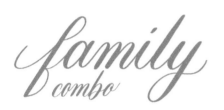

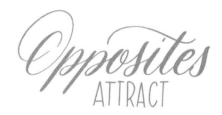

Family combination:
Similar to font families in typography, different sizes and weights of a single hand-lettered style go well together.

Serif and sans serif:
Serif and sans serif, when used at different sizes, pair well and add interest.

Opposites attract:
Mixing a script style with a non-script style often works well and adds contrast.

So what *doesn't* work well? There are no strict rules as far as what absolutely won't work. Generally, using more than two or three styles in one composition will make the piece appear cluttered. See the example to the right.

Combining styles that are closely related but not quite the same will sometimes look like an unintentional error (as though you meant to use the same style but accidentally used two different ones). Your piece might look disorganized or chaotic like this example.

A Simple Composition How-To

In the next chapter, I'll walk you step-by-step through eight fun and simple projects. You'll be able to create stunning pieces even before mastering your own compositions. But before we get to a finished project, let's go over elemental compositions. These are the foundational steps to creating your own successful design.

When starting any composition, begin with a series of pencil sketches. Although the sample illustrations so far in this book look polished and digitized, I can assure you that all of them were initially drawn by hand with pencil and paper. During the initial steps, I use my normal (often messy) handwriting to develop my idea. Use the following steps to create a basic composition.

1. Choose a short quote or phrase and write it out on a piece of paper. If there are words that you want to emphasize in your design, circle them. Write the phrase in your normal handwriting or in capital block letters so you can get a sense of length and spacing. For this example, I chose to illustrate the sentence "Creativity is intelligence having fun." My goal is to try to emphasize the words "having fun" in my different compositions to make them playful.

2. Draw 10 to 12 small squares on a sheet of paper to make "thumbnail" sketches. In each square, sketch out the words in a different style. If you feel overwhelmed thinking about styles or spacing, continue drawing the letters in capital block letters or in your regular handwriting. These should be quick sketches—they are your roughest drafts, and they're an essential step in brainstorming. Focus on coming up with different variations, not on finalizing a perfect layout.

These thumbnail sketches below are drawn quickly so I can get an idea of what will work. Several of these ideas might work well, but because this exercise focuses on a simple composition, I won't choose anything that is overly illustrated, such as a banner or three-dimensional lettering. If you're using a quote, it's good practice to attribute the quote somewhere in the design.

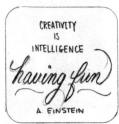 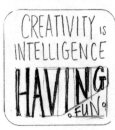 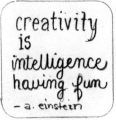 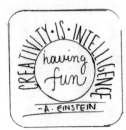 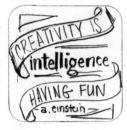

3. Once you have filled a page with thumbnail sketches, decide which one you think will work best. For the purpose of this exercise, don't draw a whole second page of thumbnails. This is a simple composition, and it's okay if it's not perfect. This exercise is more about getting used to the steps of composition design, so choose one option and keep moving forward. Your mantra for this exercise should be "Finished is better than perfect."

The thumbnail sketch in the Step 3 image is the one I chose to move forward with. The closely placed descenders of the *g* in *having* and the *f* in *fun*, along with the swash off the *n* in *fun*, inspired me to incorporate playful but simple flourishes. I'll refine them further in my next drawing.

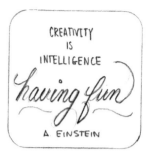

Step 3

4. Get a new sheet of paper, and decide whether you need to alter the shape of the original composition. Maybe you drew rectangular thumbnails, but your piece will fit better in a square configuration. Lightly sketch out your lettering with a pencil. Use a ruler to make guidelines or grids. As you refine the drawing, build up letters or erase grid marks. If your sketch gets messy, retrace the design on a new sheet of marker or tracing paper. Adjust lettering and spacing where it still looks off. If your design is meant to be asymmetrical, make sure it is clearly off-center.

As you can see in the Step 4 image, my composition is still roughly drawn. I've added guidelines with a ruler to ensure that my letter heights are consistent. My sketch is not precisely centered, but I will measure the spacing again to ensure it's correct before retracing it a final time.

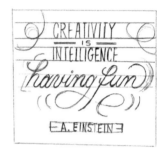

Step 4

5. Once you are happy with the final pencil sketch, ink over your work with a brush pen, monoline pen, or marker.

As you can see in the Step 5 image, I've chosen a monoline style for this composition, so the final ink on this is a little shaky. That's part of hand lettering—I'll fix it in the digitized version.

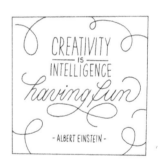

Step 5

6. To smooth out my lettering without re-creating the entire composition, I took a photo of this sketch with my iPad and traced it with an Apple Pencil using the iPad illustration app Procreate. For step-by-step instructions on digitizing your work without an iPad, see Digitize Your Lettering (pages 129-134).

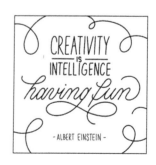

Step 6

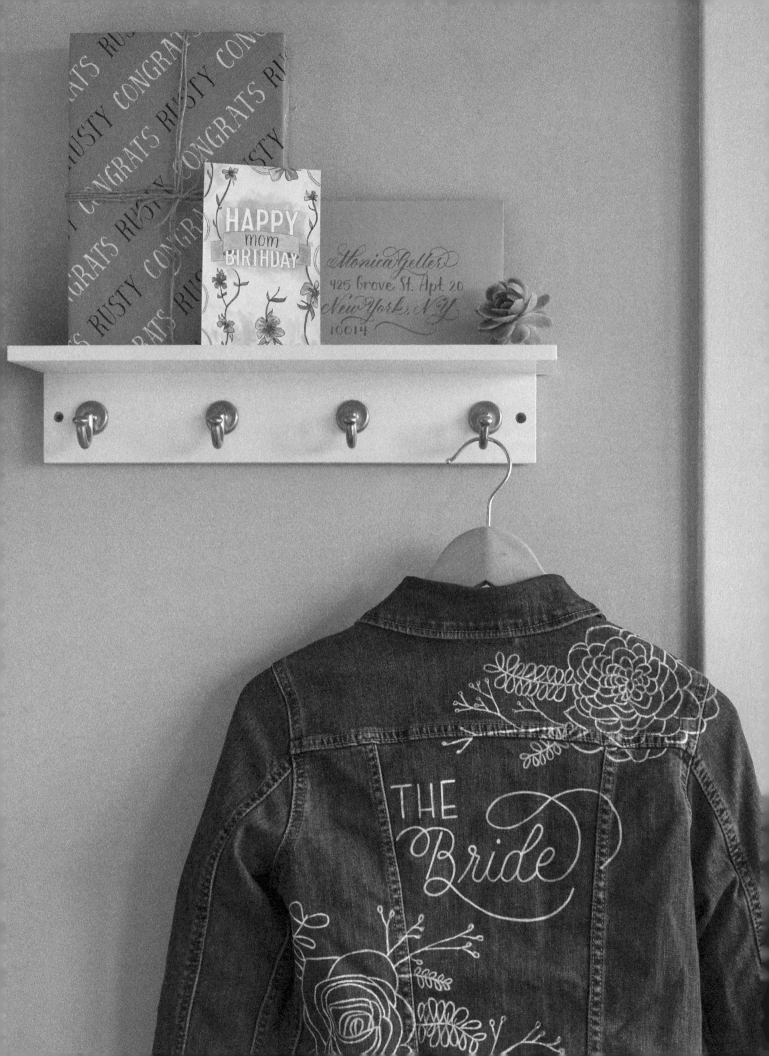

Chapter Six
Eight Simple Projects

Uses for lettering—from murals and sign painting to personalizing consumer goods—are limitless. Whether you're making a gift, a craft to sell, or something for your own home, the technique of applying lettering to a variety of surfaces is a highly sought-after, valuable, and versatile skill.

In this chapter, we'll tackle eight different projects to apply lettering to paper goods, leather, fabric, coated plastics, and chalkboards. All crafts are made using the alphabets you learned in chapters 3 and 4. Each project includes a small thumbnail of the text to draw and full-size printable online at CallistoMediaBooks.com/easycreativelettering. These are not complex, aspirational projects—they are entirely doable using the skills you've already learned in this book!

Harry Potter
4 Privet Drive
Little Whinging
Surrey

Monica Geller
425 Grove St. Apt. 20
New York, NY
10014

PLEASE DELIVER TO:
M. Mouse
1180 Seven Seas Dr.
Lake Buena Vista, FL

Happiest Happy Mail
MIXED-STYLE ENVELOPES

Wrapped in twine and tucked into a cozy corner drawer of my studio is a bundle of hand-lettered envelopes addressed to me. When I began lettering, I often exchanged "happy mail" with new lettering friends, and I kept everything that I received. It was a great way to practice centering addresses, mixing styles, and getting fancy with illustrations and flourishes. This first project will challenge you to create your own mixed-style addressed envelope.

1. Download, print out, and cut the envelope guide shown below from CallistoMediaBooks.com/easycreativelettering.

2. Double-check your postal service website for mailing restrictions on elements like envelope sizes, borders, and required postage space. In the United States, an A7 size envelope must have a bottom border of ⅝ inch and a ½-inch border on the left- and right-hand sides.

3. Use scrap paper to practice writing each line of text for the address. Once you master lettering envelopes, you can skip this step. For now, writing each line in advance will help you get an idea of length and spacing. If one line is too long to fit across the envelope, consider how you can abbreviate it, or move a portion of the address to the next line. Apartment numbers, for example, can be set on a second address line, below the street name and number. Try using two different alphabets (one script and one serif/sans serif) and play around with mixing styles.

4. Insert the envelope guide into an envelope with the lines facing the front side. Hold the envelope up to a tablet or a window so you can lightly trace the lines onto it in pencil. If you're using a darker or heavier paper stock that you can't see through to trace, set the envelope guide to the left or right of the envelope. Place an 18-inch ruler on top of the envelope guidelines and across the envelope. Use a pencil to extend the guidelines onto the envelope.

5. Write on the envelope slowly, one line at a time. I recommend keeping your scrap-paper practice address next to you so you can reference both spacing and letterform design.

6. Use an eraser to remove pencil marks. If the envelope guide is still inside, don't forget to remove it and save it to use again!

VARIATION TIP: Mangrove (page 56) and Sawgrass (page 88) are another great alphabet pairing for this project!

Sample of envelope guide

Tools and Materials

- Pencil
- Scrap paper
- Monoline pen
- A7 size notecards
- Monoline embossing pen
- Metallic embossing powder
- Small paintbrush (for brushing away excess embossing powder)
- Heat gun for embossing

Attitude of Gratitude
FANCY THANK-YOU NOTES

A heartfelt, hand-lettered thank-you note serves as a thoughtful (and beautiful) gesture of gratitude. Instead of sending a quick text, use this thank-you note project to make someone's day special. I've even received thank-you notes in response to my thank-you notes—maybe you will, too! This project features embossing, which involves using a heat gun. It might take a couple of tries to get the hang of the heat gun and its effect on embossing powder, so before you do this on a meticulously lettered card, try the technique out on scrap paper!

1. Download and print out the full-size words from CallistoMediaBooks.com/easycreativelettering.

2. If you choose to hand letter your own design, sketch it out on scrap paper first. After you've settled on your final design, use a monoline pen to ink the drawing so it's easier to trace.

3. Prepare to emboss. When embossing, clean hands are essential! Wash and dry your hands thoroughly—the oils from your hands may interfere with the embossing powder, preventing it from properly adhering to the card.

4. Hold the card up to a window or tablet. Using a pencil, lightly trace your design of choice onto the card.

5. Now trace the penciled-in design with the embossing pen. The embossing pen uses clear ink that will barely leave a mark on your paper. Fill in the faux-calligraphy downstrokes to create a faux brush-lettered look, as demonstrated on page 24.

6. Next, sprinkle a generous amount of embossing powder onto the card, covering your design completely.

7. Once your design is covered, pour off any excess embossing powder onto a sheet of scrap paper to conserve it. Gently fold the scrap paper to create a funnel and return the unused powder to its original container. The embossing powder should stick to the lettering that you traced with the embossing pen.

8. Lift your card up and tap it deliberately on its side atop the scrap paper. This should knock any remaining excess powder loose. If a few stray pieces of powder remain, gently brush them away with a dry small paintbrush.

9. Melt the embossing powder. This is a quick step and it's easy to overheat the powder, so you'll need to work swiftly. Hold the heat gun a few inches above the paper and turn it on. Using small, circular motions, direct the stream of hot air toward your design. It will only take a few seconds for the embossing powder to melt. Overheating will scorch the paper, so be sure to turn the heat gun away from your card as soon as the embossing powder has melted.

HEADS UP: Using specially formulated antistatic tools with embossing powder, such as a powder-filled sachet, will help keep stray particles of powder from sticking. Look up *"antistatic pouch for embossing"* online.

Alphabet for this project
Starfish (page 76)

Tools and Materials

- Carbon paper (or see DIY carbon paper instructions in step 2)
- White card stock
- Pencil
- Eraser
- Gouache or watercolor paints
- Paintbrush, round #2 watercolor brush or similar
- Gel pen
- Small brush pen
- Scrap paper

This Is Your Gift

BRILLIANTLY STYLED BIRTHDAY CARD

Handmade birthday cards are the ultimate accompaniment to any gift and even make a great gift on their own. I think we all write "Happy Birthday" more than almost anything else, and you can practice your favorite lettering style to personalize the card with a name. You'll use gouache or watercolor to fill in the letters. Go ahead and make half a dozen of these cards at once and personalize them for all your friends—I won't tell anyone!

1. Download and print out the full-sized *Happy Birthday* image from CallistoMediaBooks.com /easycreativelettering.

2. Use carbon paper to transfer the design to white card stock. If you don't have carbon paper on hand, you can create your own: Rub the side of a pencil tip on the back side of the *Happy Birthday* design. Cover the paper completely with graphite—it might take a few layers of shading. Place the sheet, graphite-side down, on top of the card stock. Trace over the design using a pen or pencil. Lift the paper—the graphite should have transferred onto the card stock. Clean up any excess graphite that transferred over with an eraser.

3. Use gouache or watercolors and a paintbrush to carefully paint the design. Gouache is similar to watercolor but has a more matte and opaque finish.

4. Use a gel pen to add polka dots or simple floral or botanical designs. Get creative and try a patterned background with solid-colored text or vice versa. Use embellishment techniques to outline the lettering or create a 3D effect with shading (see pages 102-103).

5. Using a brush pen, add the name to the banner. To perfect the spacing of a name, practice writing it on scrap paper. Measure the name and make a mark on the banner in pencil to indicate where to begin lettering. The sample project uses my Starfish alphabet, but a script alphabet also works well with the big block letters in *Happy Birthday*. Try making your own card design using the Sea Grape alphabet (page 44) for *Happy Birthday* and the Starfish alphabet for the recipient's name.

SHORTCUT: You can print this design directly onto card stock and paint it with gouache. Gouache paint is opaque and will completely cover black printer ink.

Alphabets for this project

Cypress (page 70) and Magnolia (page 32)

Tools and Materials

- Scrap paper (8½ by 11 inches)
- Pencil
- Eraser
- Roll of kraft paper
- Ruler
- Brush pen or gel pen
- Scissors
- Double-sided tape
- Ribbon

All Wrapped Up
SIMPLY ELEGANT GIFT WRAP

When I was little, I loved wrapping gifts. Creasing the paper and tying ribbons and bows was as satisfying to me as a slime video is to kids today. I've found that lettering on solid wrapping paper ensures that I always have occasion-appropriate gift wrap available. With a little lettering practice, your new time- and money-saving technique will save the day and impress gift recipients. Just wait and see—they won't want to tear the paper!

1. Using scrap paper, sketch your design. We'll use the same process here that we learned in A Simple Composition How-To (pages 104-105). Brainstorm your ideas by drawing several thumbnail sketches. Simple designs that repeat work best.

2. Once you've decided on a design, sketch it out larger on the 8½-by-11-inch scrap paper. Try wrapping the paper around a small box to ensure that the design works as a pattern and that no ornate details are lost in the folds. Wherever possible, incorporate the gift recipient's name to make your wrapping paper more personal!

3. Unroll several feet of kraft paper onto your work surface. If your pattern needs to follow a straight line, mark out rough guidelines with a ruler.

4. Letter your design on the wrapping paper using a brush pen or gel pen. Erase any pencil marks.

5. Wrap your gift using double-sided tape and tie it with ribbon!

SIMPLIFY IT: When wrapping larger gifts, use a large brush pen and widely spaced lettering patterns.

Alphabets for this project

Mangrove (page 56) and Sawgrass (page 88)

Tools and Materials

- Ruler
- Small framed chalkboard sign
- Pencil
- Scissors
- Carbon paper (or use the DIY carbon paper method in step 4)
- Artist tape
- Chalk marker
- Eraser

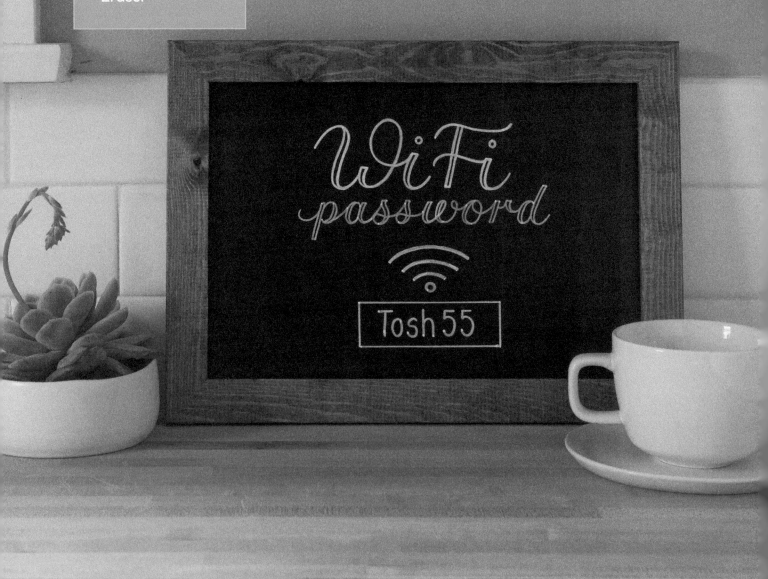

Charming Chalk Signs
CUSTOMIZED SIGNAGE

Custom signage is popping up everywhere. If you haven't noticed it already, you will now that I've mentioned it! Weddings and other special events that require directional or tabletop signs are a great place to try out the technique used in this project—lettering on a chalkboard. We'll go step by step to create a chalkboard sign for your home, complete with a traceable design. After completing this rustic craft project, you can confidently re-create it with your own lettering for any occasion.

1. Download and print out the full-size image from CallistoMediaBooks.com /easycreativelettering.

2. Measure the design and the chalkboard. Mark in pencil where the lettering design should begin. For this 7-inch-wide design on a 12-inch-wide chalkboard, I measured off and marked vertical lines 2½ inches from the left and right sides. The drawing for this project is 6 inches tall, and the chalkboard is 8 inches tall, so I marked horizontal lines to create a 1-inch margin at the top and bottom.

3. Trim around the design with scissors and discard any excess paper.

4. Place the printed illustration on the chalkboard with a piece of carbon paper sandwiched in between. (If you're using the DIY carbon paper method, cover the back of the printed design with graphite by rubbing it with the tip of a pencil. It might take a couple of passes to get enough graphite onto the paper. Place the design, graphite-side down, on the chalkboard.)

5. Tape the design to the chalkboard using artist tape. (Note: You could use washi tape, but it's not as sticky. You can use masking tape, but it often leaves residue behind. Artist tape is my go-to for nearly everything.) Check twice to ensure that the design is centered.

6. Using a pencil, trace the design with enough pressure to transfer the carbon or graphite to the chalkboard. To ensure the graphite is transferring, gently lift the tape and peek.

7. Peel the tape off the chalkboard and set the printed design aside. If you are using this method to make several signs for a wedding or another event, reuse the same paper to trace the design onto multiple chalkboards.

8. Using a chalk marker, trace over the pencil on the chalkboard. Go over it a second time if it is not opaque enough.

9. Erase pencil marks with an eraser.

VARIATION TIP: If you're creating signs that will not be reused, use an acrylic paint pen instead of a chalk marker for bold lettering.

Random aside: Until I got a new Internet provider, my WiFi password was "qpz?rih%5w=6." We had it memorized, and we'd recite it aloud to anyone who visited Casa Briggs. Feel free to use this or my dog Tosh's birthday as your password. High fives if you also have a cache of impossibly long passwords stored in your brain.

Alphabet for this project
Tortuga (page 64)

Tools and Materials

- A5 size hardcover notebook
- Ruler
- Pencil
- Carbon paper (or use the DIY carbon paper method in step 5)
- Artist tape
- Acrylic paint pen (I recommend Molotow Liquid Chrome)
- Scrap paper
- Paper towels
- Eraser

create every day

Sparks of Inspiration
PERSONALIZED BUJO (BULLET JOURNAL) NOTEBOOK

My entire life is outlined in journals. I use one as a sketchbook, my monthly calendar, and a place to track habits and weekly goals. Since it's both an idea book and an agenda, it helps me stay focused on what's most important and, at the same time, provides space for my creativity to flow. If I need two pages to outline a particularly busy day ahead, there's space for that. An entirely blank canvas is a window to every opportunity you didn't even know you wanted. Personalize a notebook for yourself, or make one for a friend!

1. Download and print out the full-size *create every day* image from CallistoMediaBooks.com /easycreativelettering.

2. If you'd like to create your own design, choose a phrase to letter and follow the steps outlined in A Simple Composition How-To (pages 104-105). For an A5 size journal, a final design of about 3 by 6 inches allows for a 1-inch border on all sides.

3. If you are using a plastic-coated or faux leather journal, wipe the surface gently with a baby wipe and allow it to dry. These journals pick up oils from your skin, which can prevent acrylic paint from adhering evenly.

4. Use a ruler to measure the journal and mark the design placement with a pencil.

5. Tape the design and carbon paper down onto the notebook using artist tape. Trace with a pencil to transfer the design to your notebook cover. (If you're using the DIY carbon paper method, cover the back of the printed design with graphite by rubbing it with the tip of a pencil. It might take a couple of passes to get enough graphite onto the paper. Tape the design to the notebook, graphite-side down.

VARIATION TIP: To add embellishments, try using a Molotow ONE4ALL marker with a 1 mm tip. The ONE4ALL allows you to draw thin lines that are perfect for adding details and flourishes.

Then, trace the design with the pencil to transfer.)

6. Remove the tape and printed design and set aside.

7. Shake the acrylic paint pen before opening and test the flow of the pen on scrap paper. (When not in use, these pens tend to dry out at the tip, which prevents even flow.) Gently press the tip onto scrap paper to resume flow and prime it with fresh paint. If you see a puddle of paint when you apply pressure, grab a paper towel and gently pull the tip out of the pen. Blot off the excess paint and reinsert the tip into the pen. Give the pen a few minutes for the excess paint to soak into the dried-out tip.

8. Trace over the pencil design with the paint pen. The Molotow Liquid Chrome paint pen has a mirror-like effect that intensifies with a second application. Trace a second time to get a more polished finish.

9. Allow the paint to dry and erase any pencil marks.

create every day

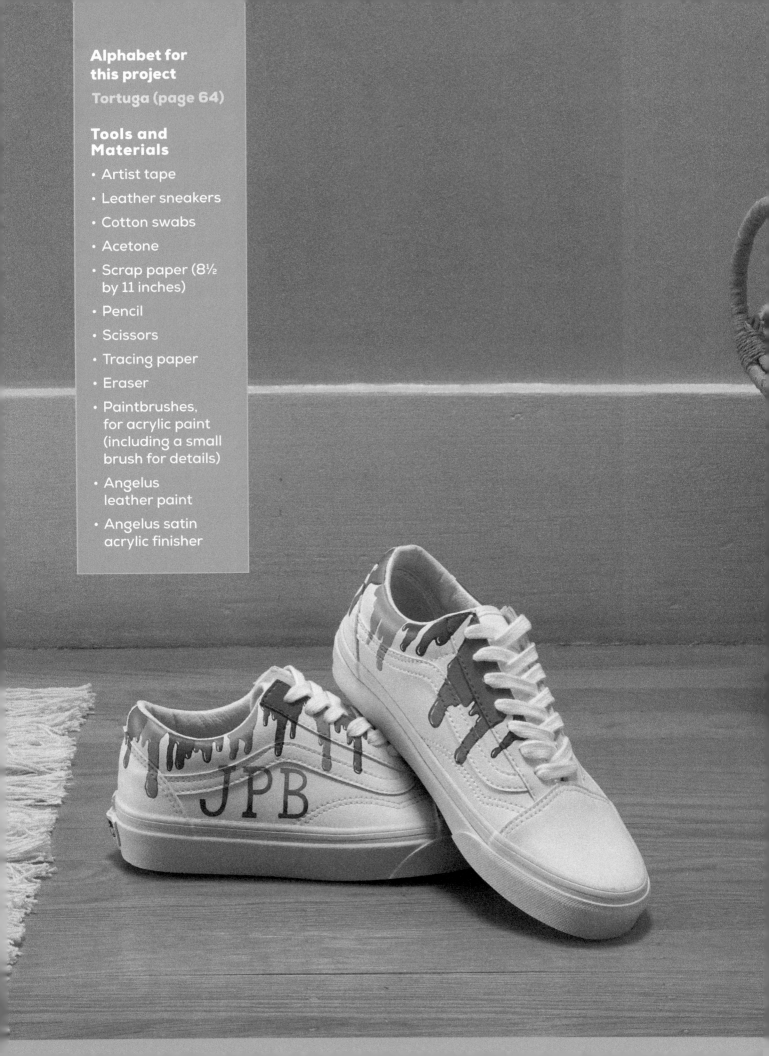

Alphabet for this project
Tortuga (page 64)

Tools and Materials

- Artist tape
- Leather sneakers
- Cotton swabs
- Acetone
- Scrap paper (8½ by 11 inches)
- Pencil
- Scissors
- Tracing paper
- Eraser
- Paintbrushes, for acrylic paint (including a small brush for details)
- Angelus leather paint
- Angelus satin acrylic finisher

Creative Customs
MONOGRAMMED SHOES

We're keeping these projects light and fun, but lettering can be a serious business. All the projects outlined in this chapter have the potential to make you some money. Stop what you're doing and look up custom sneakers: You'll find everyday sneakers, athletic shoes, cleats, dress shoes, and more. The allure of a personalized design is on-trend, and there's nothing more one of a kind than your own monogram on your own shoes.

1. Prepare the surface of your sneaker and protect the areas you won't be painting. Use artist tape to tape off the midsole and collar. Remove the shoelaces. Dip a cotton swab in acetone and dab it on the surface area you are going to paint. Acetone will remove the finish on the leather and make it dull, so be careful to use it only on the portions of the shoe that you will be painting. Plan to paint entire sections or leave them with the original finish. For my sneakers shown in this picture, the background has been treated with acetone and then painted white!

2. On the scrap paper, sketch your lettering or other design in pencil at the exact size you want it to be on your shoes. Use scissors to cut out the design.

3. Transfer the design to the shoe. Place tracing paper on top of the design and trace it neatly with a pencil. Flip over the tracing paper and trace the reverse side with a pencil as well, creating makeshift transfer paper. Place the tracing paper on the chosen area of the shoe and use artist tape to tape it securely into place. Trace over the design firmly with a pencil. The graphite on the reverse of the tracing paper should transfer onto the sneaker. Remove the tracing paper and tape. Clean up any stray graphite marks with an eraser.

4. To replicate the dripping paint effect, trace or practice drawing the samples below.

5. Paint the design in even, thin coats and allow to dry completely in between. Thin layers will adhere best to the sneakers. For durability and long-lasting wear, paint three or four thin layers to ensure complete coverage and eliminate brushstrokes. Seal the paint by applying a thin coat of Angelus satin acrylic finisher with a paintbrush.

SIMPLIFY IT: Fill empty Molotow paint markers (available online) with a mixture of leather paint and Angelus 2-Thin paint thinner to create your own leather paint markers.

Draw tear-shaped paint drip outlines in pencil.

Fill in the drips with paint and outline in black or a slightly darker tone of the same color (add a little black paint).

Add highlights on one side of the paint drip with white paint and a liner brush.

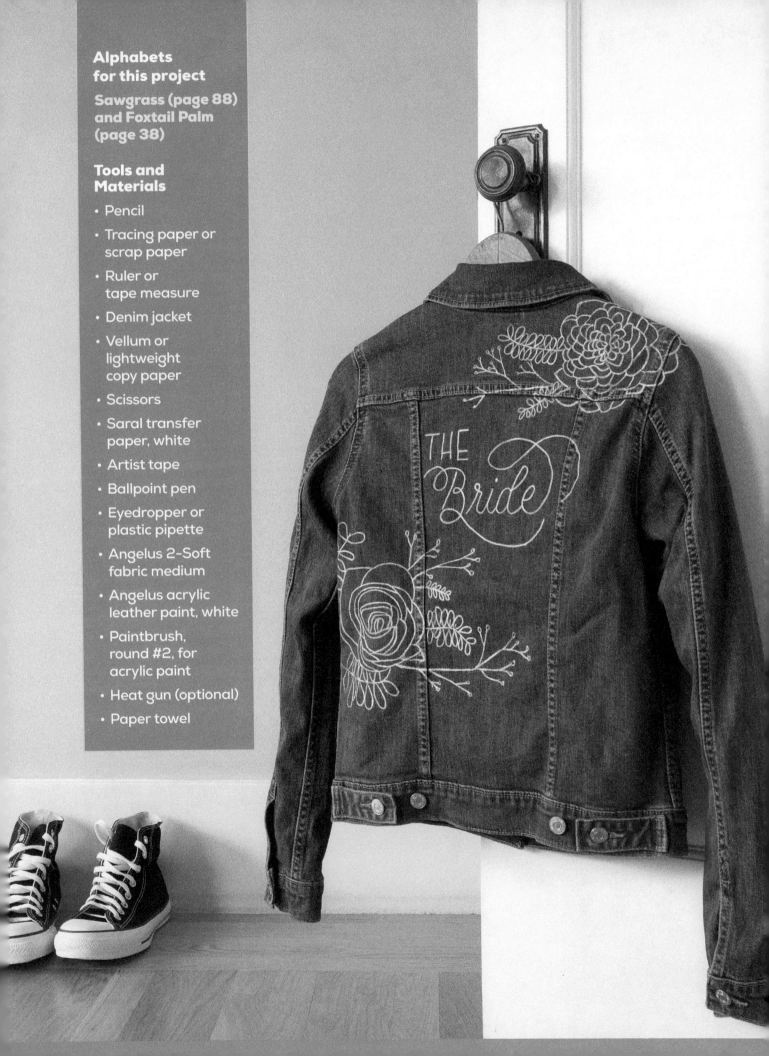

Alphabets for this project
Sawgrass (page 88) and Foxtail Palm (page 38)

Tools and Materials

- Pencil
- Tracing paper or scrap paper
- Ruler or tape measure
- Denim jacket
- Vellum or lightweight copy paper
- Scissors
- Saral transfer paper, white
- Artist tape
- Ballpoint pen
- Eyedropper or plastic pipette
- Angelus 2-Soft fabric medium
- Angelus acrylic leather paint, white
- Paintbrush, round #2, for acrylic paint
- Heat gun (optional)
- Paper towel

Darling Denim
DIY BRIDAL JACKET

This jacket will keep the bride-to-be warm, but it's also adorable for wedding week activities and photo ops—not to mention it will make her day that much more special. This project and the tools and materials might seem a little intimidating, but if you follow the instructions step by step, you'll find it's not as complicated as it appears! For this project, it's important to use the correct technique to apply the paint to the fabric so it lasts without cracking or fading. You can use these instructions to create designs that revive an old favorite pair of jeans or a cotton-canvas tote bag—the application method is the same!

1. Copy or trace the designs on the next few pages. You can also download and print the full-size design from CallistoMediaBooks.com /easycreativelettering.

2. Measure the back of the denim jacket. Resize the lettering and flower design if necessary and print the design onto vellum or light-weight copy paper. With scissors, trim away the excess paper, leaving only the design and a ½-inch border on all sides.

3. Measure and cut a piece of white Saral transfer paper that is slightly larger than the printed design. The Saral paper will work similarly to carbon paper, transferring the design in a chalky residue that won't damage the fabric.

4. Place the Saral paper, chalky-side down, on the denim jacket. Place the printed design on top. Tape both the Saral paper and design print to the fabric so they remain firmly in place while you trace.

5. Using a ballpoint pen, trace the drawing. Use firm pressure to ensure the chalky residue from the Saral paper transfers the design cleanly onto the denim.

6. Remove the tape, printed design, and Saral transfer paper and set aside. Save the Saral paper to reuse with another design.

7. Using an eyedropper or plastic pipette, mix equal parts of Angelus 2-Soft fabric medium and white Angelus leather paint in a small dish. This combination will create a perfect fabric paint that will remain flexible and soft.

8. Use the paintbrush to trace the design with the leather-paint mixture. The first layer of paint will be almost transparent. It is important to let the first layer soak into the fabric and dry completely before you continue. If you'd like, use a heat gun to set the first coat. You may need to apply up to four coats of leather paint to ensure an opaque white finish. This may sound tedious, but thin, even layers will result in a durable finish that will remain flexible and won't crack. If you are painting a smaller design or are not as concerned with durability, you can get the job done in fewer coats of paint by using a lower ratio of Angelus 2-Soft fabric medium.

9. When you're finished painting and the jacket has dried, gently pat away any chalk markings left behind by the Saral paper with your hand or with a damp paper towel.

VARIATION TIP: To edit the jacket after the wedding, paint a large white oval shape directly over "The Bride." Then, letter the bride's favorite quote or catchphrase on top with a mixture of navy and white paint to match the denim.

EASY CREATIVE LETTERING

til you

right.

actice

can't

practice

you get

ht. wron

ice until

Digitize Your Lettering

Digitizing your lettering will give you the flexibility to share and reproduce designs quickly. The first two steps are the same regardless of which program you use. I've included instructions for the later steps in a few different programs: Adobe Photoshop (Creative Cloud 2020), Adobe Illustrator (Creative Cloud 2020), Inkscape (0.92.4), Cricut Design Space, and Silhouette Studio. For a complete visual reference guide to these steps, download the pdf from CallistoMediaBooks.com /easycreativelettering.

1. **Prep.** Preparing your work for digitization is as simple as inking a design and cleaning up any stray pencil marks left behind. If it's pretty messy, retrace the entire drawing in ink. The cleaner the design, the less work you'll have to do to clean it up digitally.

2. **Scan.** Use either a smartphone or scanner to capture your design. Scan with a resolution of at least 300 dpi and a maximum of 600 dpi. If you are taking a photo of your work with a smartphone, photograph it from directly above the design with bright, natural lighting to reduce shadows and glare. Using the phone's photo editor, adjust the exposure and contrast as much as possible to come up with an image that's closest to black and white.

3. **Refine and save.** Choose any of these three programs to produce a print-quality final result.

 - **Adobe Photoshop** will allow you to save the image as a high-resolution raster file (jpeg, png, tiff, etc.), which is usable at the original size or smaller.
 - **Adobe Illustrator** can resave your image as a vector file (ai, svg, eps, pdf, etc.), which is useful for scaling images up to the size of a dump truck if you need them that large.
 - **Inkscape,** an open-source, free software, creates a vector file (svg, eps, pdf, etc.).

continued from page 129

Digitize with Adobe Photoshop

4. In the top menu, select File > Open.
5. In the top menu, select Image > Adjustments > Levels.
6. In the Levels dialog, adjust the sliders below the input levels histogram to create a completely black-and-white image. Move the slider on the right (highlights) to the left past any peaks on the highlights portion of the histogram. Move the slider on the left (shadows) to the right past any peaks on the shadow end of the histogram scale.

Move slider left for white adjustment.

Move slider right for black adjustment.

7. Click File > Save As to save as a file.

TO SAVE THE FILE WITH A TRANSPARENT BACKGROUND

8. Select the Magic Wand tool from the left menu.
9. Click on the lettering to select it. If any areas are not selected, right-click on them and select Similar.
10. In the top menu, select Layer > New > Layer Via Copy.
11. In the Layers panel, right-click on and delete the background layer.
12. Click File > Save As to save as a file with a transparent background.

continued from page 129

Digitize with Adobe Illustrator

4. In the top menu select File > Open and select your design. (Resize it to fit the artboard if needed, using Object > Transform > Scale.)

5. To open the full Image Trace panel, select Window > Image Trace.

6. Select the design with the Selection tool. In the Image Trace panel, choose Sketched Art or Black and White Logo from the Presets dropdown menu.

7. If you need a smoother result, go into the Advanced section of the Image Trace panel. Increase the Threshold and reduce the number of Paths and Corners.

8. Next, click Object > Image Trace > Expand to unlock the vector tracing.

9. With the entire image highlighted, select Ungroup with the shortcut Command + Shift + G (Shift + Control + G for Windows). Illustrator supports multiple groupings. To ensure everything is ungrouped, you need to repeat the shortcut a few times. The design is now a traced vector that includes both the black lettering and the white background. To delete the white background (which you cannot see because the artboard is also white), continue with steps 7 through 9.

10. Click the Direct Selection tool and select the entire design. Click Delete. Then select each of your counters and bowls and click Delete. This will ensure that the counters are removed (they look white, but they will read as a solid object).

11. To further refine rough edges: Click the Direct Selection tool and edit individual anchor points along the vector path. If you prefer a rough handwritten look, skip this step.

12. Click File > Save As to save as a vector file.

continued from page 129

Digitize with Inkscape

4. In the top menu, select File > Open and select the image from your computer.

5. In the top menu, select Path > Trace Bitmap. A new dialog box will open.

6. Select Autotrace from the dropdown and select OK. Close the Trace Bitmap dialog box.

7. Click on your image and move the traced image (currently directly on top of the original) over to the side and away from the original jpeg. Click on and delete the original jpeg.

8. To delete bowls and counters: Select the Edit Paths by Nodes tool in the left menu (second from the top). Then select Path > Difference.

9. To further refine and edit nodes: If you need a completely clean edge on your lettering, you will need to edit the path around each letter node by node. Click F2, and all the nodes around the design will appear as dots. Double-click to highlight an individual node (in red). From there, you can click Delete to omit the node, or click and drag to edit. If you prefer an authentic handwritten look, skip this step.

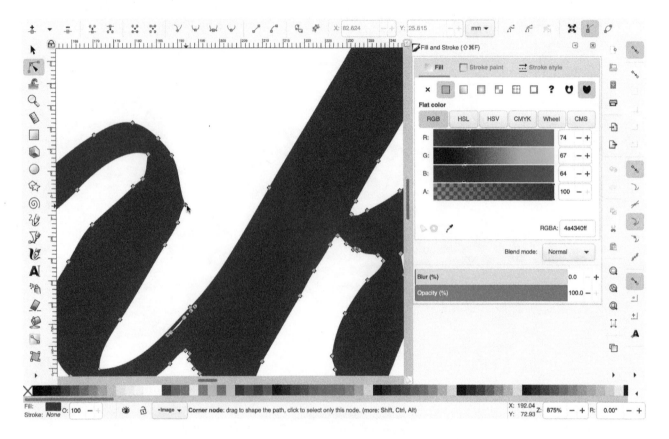

10. Click File > Save As to save as a vector file (eps, svg, pdf, and more).

Digitize with Cricut Design Space or Silhouette Studio

Thinking of using a cutting machine to create vinyl and paper crafts? The proprietary software included with both Cricut and Silhouette has impeccable tracing functionality. Take a photo of your work with good contrast and import it as a jpeg. Both systems are user-friendly with on-screen prompts to guide you every step of the way.

Resources

A Complete Shopping List

Amazon.com/shop/missybriggs—A curated list of favorite lettering and craft supplies. This list only includes materials I use—it's not padded with extras.

Acrylic Paint Pens

Molotow.com—Corporate site for Molotow brand acrylic paint pens. Also includes videos for creative inspiration and some how-tos.

Leather and Fabric Painting

AngelusDirect.com—Corporate site for Angelus leather paints. Includes shopping, tutorials, and FAQs on leather painting and application.

YouTube.com/user/DDeJesus6—YouTube channel of sneaker artist Dillon DeJesus (@dejesuscustomfootwear; DeJesus Custom Footwear). Tons of tutorials, tips, and tricks for beginners to customize sneakers.

Brush Pens

JetPens.com—All the brush pens, plus an option to buy brush-pen sampler sets.

Traditional Pointed Pen Calligraphy

IAMPETH.com/lessons—Your first stop on the train to pointed pen scripts. Free resources guide with video lessons.

More from Me

MissyBriggs.com—Oh, hey. That's my site! It's chock-full of lettering how-tos, applications for creative lettering, and more free guides.

More Lettering Practice and DIY Inspo

See who I follow on Instagram! The list there is really long, but you'll find my friends who dedicate their Instagram feed to inspiring or teaching *you* about lettering. I follow a lot of other artists who inspire me daily, so really . . . check out the entire list of humans. I find them to be a resource on the daily. Isn't community a beautiful thing?

A NOTE: Be mindful and grateful when utilizing the work of others as a resource. Does the artist provide free information and tips? Give them a shout-out or comment on and like their material. I invite you to consider financially supporting work from an artist you love. If an artist who inspires you is charging for resources, consider paying the fee—the resources will enrich your life and your work, and most fees won't break the bank.

Index

Acknowledgments

Sharing my love of creative lettering is a privilege. I'd like to thank the entire team at Callisto Media for the opportunity to share my art and DIY skills with the world.

Special thanks and forever gratitude to my family: to My Love, my husband Tony Briggs, my biggest supporter and source of inspiration; my children Rusty and Chica, who ask all the hard questions and remind me why I show up to create every single day; and my parents and nuclear family of origin, who have been my forever supporters and given me the confidence to pursue a creative career.

A heartfelt thank-you to my Miami mom-crew of friends for their endless support as I wrote this book. Thanks for checking in with me and for picking up my kids—it takes a village!

I'd like to thank the lettering and calligraphy community on Instagram. After years of living in a creative desert, I found my home with all of you.

Many thanks to all of my art teachers through the years, with special thanks to the late Darby Bannard, my painting professor at the University of Miami. He taught me to think and work abstractly and brokered the sale of my first painting right off the wall of the Lowe Art Museum.

About the Author

MISSY BRIGGS is a full-time artist and blogger. She turns creative lettering into an approachable art form for all—especially her fellow lefties—and offers demos, tips, and tricks for her loyal following on Instagram @missybriggs. (Follow her to see the weird, bendy thumb.) As a professional artist, Missy does freelance lettering design for Fortune 100 companies and is commissioned by luxury retail brands for on-site calligraphy and monogramming. Missy is a graduate of the University of Miami with a degree in art and art history. She lives and works at her never-tidy home studio in Miami, Florida. Visit her and sign up for freebies at MissyBriggs.com.